50 Gems
of the
Cotswolds

DAVID ELDER

For Rachel and Catrin

First published 2015

Amberley Publishing
The Hill, Stroud
Gloucestershire, GL5 4EP

www.amberley-books.com

British Library Cataloguing in Publication Data.
A catalogue record for this book is available from the British Library.

ISBN 978 1 4456 4670 1 (paperback)
ISBN 978 1 4456 4671 8 (ebook)

Typesetting and Origination by Amberley Publishing.

Printed in Great Britain.

Contents

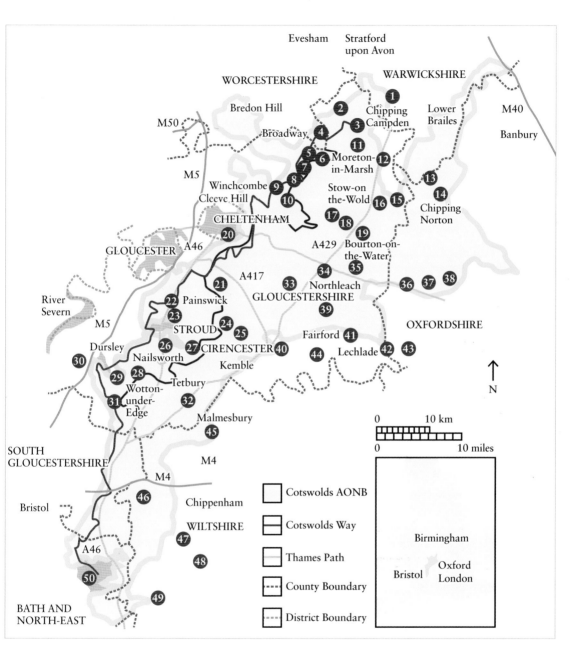

Map of the fifty gems of the Cotswolds.

Acknowledgements

I am most grateful to Christian Duck at Amberley for commissioning the book. Also, a number of organisations, societies and museum, library and archive services have provided me with excellent support. My thanks in particular go to all the staff at Cheltenham Reference and Local History Libraries, James Harris at the Corinium Museum, Nicola Finlay at Burnt Norton, Isobel Uden at English Heritage, Jade Mansell at Sudeley Castle and Joshua Nash at Berkeley Castle. I am also grateful to the following for making many helpful corrections and suggestions: Steve Blake, Michael Elder and James Ritchie. My heartfelt thanks go to my family, Meg, Rachel and Catrin, for their patience, support and encouragement.

The author and publishers would like to thank the following people/organisations for permission to use copyright material in this book: the estate of U. A. Fanthorpe for permission to reproduce 'To Cirencester from Corinium: Ave' (2004); Kelmscott Manor: Society of Antiquaries of London for permission to reproduce an extract from William Morris's poem, 'Verses for the Bed at Kelmscott' (1891); Joanna Trollope for permission to reproduce a short extract about her life in the Cotswolds from her web site, *www.joannatrollope.com*; English Heritage for permission to photograph the Rollright Stones and Minster Lovell Hall; the Director of the Corinium Museum for permission to photograph the Roman mosaics; Lorraine Dineen for permission to photograph Stanway House; David Terry for permission to photograph the Bear Inn, Bisley; Thomas Powe for permission to include his portrait in the photograph of The Circus, Bath; Paul Moir for permission to photograph Painswick Rococo Garden; James Methuen-Campbell for permission to photograph Corsham Court; the Earl of Harrowby for permission to photograph the garden at Burnt Norton; the Berkeley and Spetchley Estates for permission to photograph Berkeley Castle; Ray Canham for permission to photograph Woodchester Mansion. The images of Hailes Abbey and Lacock Abbey are reproduced with the kind permission of the National Trust. All images are copyright of the author except for 'View of the castle from the south-west' which is copyright of Sudeley Castle & Gardens.

Every attempt has been made to seek permission for copyright material used in this book. However, if we have inadvertently used copyright material without permission or acknowledgement, we apologise and we will make the necessary correction at the first opportunity.

North Cotswolds

1 Ilmington

The attractive village of Ilmington lies sheltered beneath Windmill Hill 5 miles north-east of Chipping Campden. The name probably evolved in the tenth century from Ylmandunes meaning 'at the elm grown hill'. Sadly, the village elms no longer exist, having been wiped out through Dutch elm disease.

Much of Ilmington's history is visible through its buildings, many of which have been built from iron stone extracted from local quarries, which is darker than other types of Cotswold stone due to its high ferrous content. Central to the village is the attractive Norman church of St Mary, which, while dating from the middle of the twelfth century, was almost entirely rebuilt in 1846. Inside, its interior is enhanced by a beautifully embroidered apple map based on old maps showing the location of local orchards. Today, these still yield as many as thirty-eight different varieties of apple within the village. Inside the church there are some fine oak furnishings produced by master-craftsman Robert Thompson. His signature of a carved mouse, which can be seen in eleven places in the church, is said to have been inspired by his remark about craftsmen being 'as poor as church mice'.

Also at the centre of the village, by the banked village green, is a small monument that displays a fragment of a basin used in the eighteenth century to collect water from a chalybeate spring. Originally known as Newfound Well, the spring was located a quarter of a mile to the north-west of the village. The water became famous for its medicinal properties in the treatment of leprous and scrofulous disorders and, were it not for competition from nearby spas such as Cheltenham and Leamington, the village might have developed into a major watering-place.

St Mary's church, one of the buildings built from iron stone.

Interesting associations with the village include Sir Thomas Overbury, the Elizabethan poet, who was born at Compton Scorpion Manor, just south of the village, and the biochemist Dorothy Crowfoot Hodgkin, who once lived at the handsome Crab Mill, dated 1711, and who was awarded the Nobel Prize in chemistry in 1964 for her development of protein crystallography. Also of great significance is the fact that the very first Christmas broadcast by King George V was relayed worldwide from the sixteenth-century manor at Ilmington in 1934. In fact, it was introduced by Walter Handy, a local shepherd, who, following this historic occasion, achieved minor celebrity status as the 'Cotswold shepherd', and went on to make a second royal broadcast in 1939. One final claim to fame is that Ilmington has often been considered the home of Cotswold Morris dancing. The linked handkerchief dance 'The Maid of the Mill' is one of more than twenty that are famously unique to the Ilmington Morris dance tradition, dating back over 350 years, which is still kept alive in the village today.

2 The Sub-Edges (Aston-sub-Edge and Weston-sub-Edge)

The wonderfully named neighbouring villages of Weston-sub-Edge and Aston-sub-Edge, which both sit below the edge of the Cotswold escarpment, lie on the fringes of the Vale of Evesham approximately 2 miles north-west of Chipping Campden. Both villages have long and interesting histories, including separate entries in the *Domesday Book* (1086) where they are referred to as Westone and Estune.

Weston-sub-Edge originally developed alongside the Roman Ryknild Street, now called Buckle Street, which provided an important link with Watling Street and the Fosse Way. The parish church of St Lawrence, originally built by Godfrey Giffard, Bishop of Worcester, dates from the thirteenth century, although it was heavily restored during the nineteenth century. The Giffards, a wealthy and influential family, lived for 400 years in a moated manor house, the site of which can still be seen behind the church. During the English Civil War, it is thought that the house was destroyed and the stone later reused elsewhere in the village.

Aston-sub-Edge is an estate village, which almost entirely belongs to the Norton Estate. This includes Burnt Norton, immortalised in T. S. Eliot's *Four Quartets* (1943), of which 'Burnt

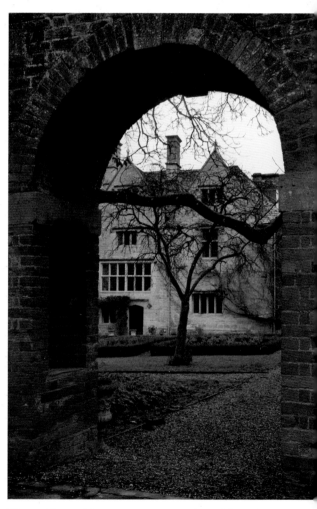

View of Burnt Norton (not open to the public) as seen through the archway that leads to the rose garden and the drained pool referenced in T. S. Eliot's poem.

Norton' is the first of four long poems. During the 1930s Eliot made several visits to Chipping Campden to visit his old college friend Emily Hale. From here he embarked on long walks with Emily in the Cotswolds, on one occasion memorably writing and dedicating a comic poem to her called 'A Country Walk' in which he describes his fear of being chased by cattle, even though he never wore 'scarlet ties', nor resembled 'a London Transport Bus'. On another occasion, in September 1934, he and Emily wandered off the road and explored the mysterious and wild garden of Burnt Norton manor house (not open to the public; visits only by prior arrangement). This experience provided him with the inspiration and much of the imagery for the poem, in which he reflects on the nature of time and the loss of innocence as well as on themes of redemption and salvation. 'Burnt Norton' has important connections with other work by Eliot: not only does it reproduce the five-part structure of *The Waste Land* (1922) but also it incorporates some discarded material from his play *Murder in the Cathedral* (1935).

While Eliot stumbled across the unoccupied house and garden, unaware of its past, its remarkable history and tale of love and betrayal has recently been brought to life in the novel *Burnt Norton* (2013) by Caroline Sandon, Countess of Harrowby and current lady of the manor. She charts the tale of how a Jacobean Cotswold farmhouse called Over Norton was built in 1620, after which a new Palladian-style mansion was built adjacent to it by Sir William Keyt. In fact, the mansion was built for Keyt's mistress, a maid called Molly Johnson, and following his abandonment, firstly by his wife, and then by his mistress, Keyt became so depressed that he deliberately burned the mansion down in September 1741, killing himself in the process. As a result of the fire, one side of the farmhouse was scorched and, thereafter, the house became known locally as Burnt Norton.

Another important character associated with the villages was the lawyer Robert Dover, who lived in nearby Saintbury and became famous for establishing the Cotswold Olympick (sic) games around 1612 in the natural amphitheatre of the hill to the south, now known as Dover's Hill. The games, which still take place annually, include events such as shin-kicking and tug o' war. The diplomat Endymion Porter, who was King Charles I's ambassador, lived at Manor House in Aston-sub-Edge and provided patronage to the games. Also of interest is the clergyman and scholar William Latimer, famous as a friend of Sir Thomas More and Erasmus, and whose abode, Latimer House, still stands in Weston-sub-Edge.

3 Chipping Campden

Chipping Campden, arguably the finest old market town in the Cotswolds, lies 2 miles south-east of Weston-sub-Edge. Dating back to at least the seventh century, it was known in Old English as Camp-denu in Saxon times, meaning 'valley with enclosures'. In about 1175, King Henry II granted the town a charter, which permitted the holding of a weekly market and annual fairs, and it was from this time that 'Chipping', which derives from the Old English word *ceping* for market, was added to its name.

During the Middle Ages, the town became one of the most important centres for wool trading, the local sheep being known as Cotswold lions because of their long, thick fleeces. Many of its oldest buildings were originally built from the wealth accrued by the wool merchants, including Grevel's House on the High Street, which was built in 1380 by William Grevel, a financier to King Richard II, also commemorated in one of the memorial brasses at the parish church of St James as the 'flower of the wool merchants of all England'. Although the church dates back to the thirteenth century, it was substantially rebuilt by the wool merchants with a magnificent tower and spacious interior.

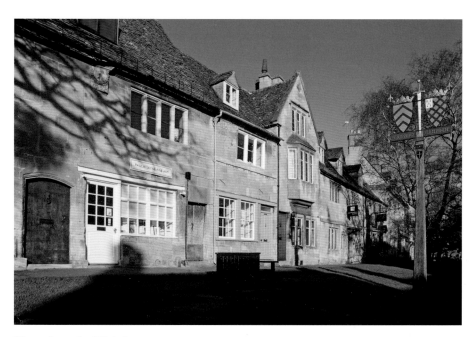

View along the High Street.

As a result of the prosperity of the wool trade, the town benefited greatly from a number of rich benefactors. These included the merchant Sir Baptist Hicks, who built a terrace of almshouses for the poor in 1612 featuring his coat of arms and Latin motto *Nondum metam*, meaning 'I have not yet reached my goal'. In addition, in 1627 he constructed a market hall, now owned by the National Trust, to provide shelter for traders.

In 1902 the town established important links with the Arts and Crafts movement when C. R. Ashbee brought his Guild of Handicraft from Whitechapel in London to Chipping Campden. As a follower of William Morris, Ashbee was drawn to the Cotswolds by its rich craft tradition. He brought with him forty craftsmen and set up workshops, which provided a model of communal living and profit sharing. Ashbee's workshop in the old silk mill on Sheep Street has now been converted into a museum and, while the guild ceased in 1910, many of the descendants of the guildsmen still carry on their crafts in the town. Ashbee's influence can still be seen in Elm Tree House, which he converted in 1904 into Campden School of Arts and Crafts, as well as in the Arts and Crafts interior features of Woolstaplers' Hall where the Ashbees lived from 1902 to 1911. Of interest too is the Court Barn museum located near the church, which celebrates a broad range of craftsmen and designers, all of whom worked in Chipping Campden and the north Cotswolds from the beginning of the twentieth century onwards. Another interesting literary association with the town is that the writer Graham Greene, as indicated by a commemorative blue plaque, stayed at Little Orchard cottage from 1931 to 1933 with his wife Vivien. It was here that he wrote his first successful novel *Stamboul Train* (1932), which was subsequently adapted into the film *Orient Express* (1934).

4 Broadway

Broadway, often referred to as the 'jewel of the Cotswolds' and now a famous showpiece village for tourists, lies 6 miles west of Chipping Campden. The village, which takes its name from the wide main street, dates back to at least the Iron Age. However, it was not until AD 972 that the first documentary evidence of an estate at Broadway, then known as Bradanuuge, was provided, when King Edgar granted a charter for the manor to the monks at Pershore Abbey. By 1250

Broadway had become a thriving market town, its weekly market having been started on the triangular-shaped village green opposite the Swan Hotel at the end of the twelfth century after the monks decided to exploit its strategic position for trade on the main road linking South Wales and London. In fact, until the Dissolution of the Monasteries, Broadway provided as much as one-quarter of the abbey's total income.

The village continued to prosper until the middle of the nineteenth century as it became an important service centre for stagecoach travel, with as many as seven four-horse coaches passing through the village daily. However, with the advent of the railways from the 1850s, the village was by-passed by the new London–Worcester railway line and suddenly fell into economic decline. Ironically, it was Broadway's reputation as a forgotten backwater that came to its rescue. Firstly, William Morris visited in 1876 and praised one of its farmhouses as a beautiful work of art. Then, in the 1880s, an Anglo-American group of artists and illustrators (which included Alfred Parsons, Edwin Abbey and John Singer Sargent), keen to escape from the squalor of the Industrial Revolution, came here to seek the perfection of the old English rural tradition. Continuing Broadway's artistic tradition today, the village now features two

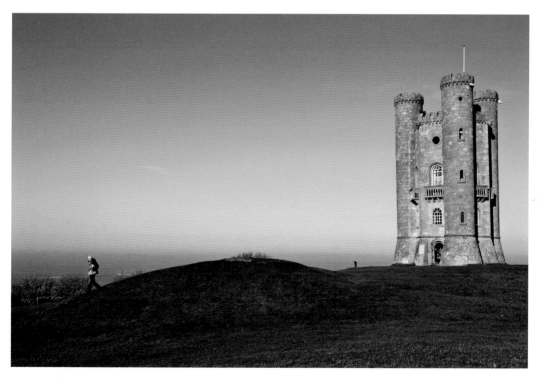

View of the tower from the south-east.

important museums, the Ashmolean Museum Broadway, located in a former seventeenth-century coaching inn, which displays paintings, objects and period furniture from the seventeenth century to the present day, and the Gordon Russell Museum, which celebrates the work of this renowned pioneer of design who was schooled in the Cotswolds' Arts and Crafts tradition.

Overlooking the village is Broadway Hill with its famous tower, which, at 312 metres above sea level, forms the highest point in the northern Cotswolds. In 1661 it was the scene of a tragic case when a mother and her two sons were hanged for a murder that, it was later proven, they could not have committed. The tower was originally built in 1798 by James Wyatt as a folly for the Earl of Coventry but since has been used for a variety of purposes – from the site for a printing press to serving as a holiday retreat for Pre-Raphaelite artists such as William Morris, Dante Gabriel Rossetti and Edward Burne-Jones. It was even used by the Royal Observer Corps during the Cold War as a nuclear-protected bunker to report nuclear attacks!

Finally, it is well worth visiting the twelfth-century church of St Eadburgha, approximately 1 mile south from the village centre along Snowshill Road, where the original site of the settlement once lay. Outside the church is a famous lychgate in memory of the American artist Francis Davis Millet, who was a member of the Broadway colony and died on the *Titanic*'s voyage. The grave of the well-known books and manuscripts collector Sir Thomas Phillipps can also be seen here.

5 Stanton

Stanton, one of the most charming villages in the Cotswolds, lies 3 miles south-west of Broadway, its single, narrow street ending at the steep ascent to the Mount Inn, ensuring that it remains today a quiet, unspoilt village. Dating back to the early Saxon period, Stanton used to belong to Winchcombe Abbey until the Dissolution of the Monasteries, and its early development was closely associated with agriculture – the origin of its name deriving from the Old English *stan tun* meaning 'farmstead within a stony enclosure'. In fact, some of the names of its buildings still reveal its farming heritage, including the thatched cottage built around 1650 at the top of the main street called Sheppey Corner

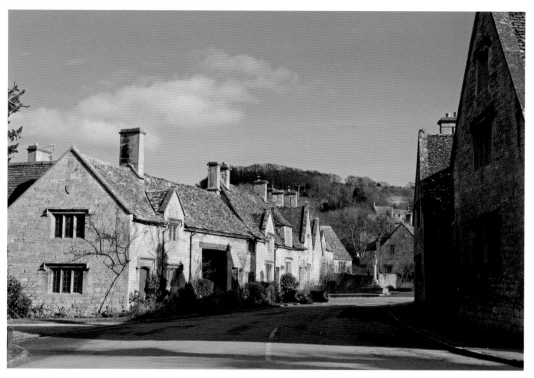

View along the High Street.

because it was once the place where the flocks of Cotswold sheep entered and left the village.

Many of Stanton's stone cottages date from between 1570 and 1650, which is often thought to be the finest period of traditional Cotswold architecture. Some of the dates still visible on the cottages confirm this. However, although most of the village looks as if it was built during the sixteenth and seventeenth centuries, much of it was in fact rebuilt or restored at the beginning of the twentieth century when a wealthy Lancastrian builder, Sir Philip Stott, moved to the manor in 1906 and spent thirty years improving the decaying village. As can be seen from the results, the work was carried out sympathetically; Stott even succeeded in filling in some of the gaps between the rows of buildings by dismantling and inserting wooden barns from surrounding villages and converting them into houses. Dove Cottage is a good example of a converted barn in this context.

Stott also employed a famous ecclesiastical designer, Sir Ninian Comper, to enhance the Norman church of St Michael's with attractive reredos and stained glass. Originally dating from the twelfth century, the church includes some fifteenth-century stained glass recovered from Hailes Abbey as well as a pulpit dated 1684, from which John Wesley preached on several occasions while

visiting friends at nearby Buckland Rectory. He often referred to the village as 'dear delightful Stanton'.

Other notable landmarks include the medieval village cross, which stands at the approach to the church, surmounted by a seventeenth-century globe and sundial; the Jacobean manor house of Stanton Court, built during the early part of the seventeenth century and extensively restored by Sir Philip Stott; and the oldest of the larger houses in the village, The Manor, also known as Warren House, built in 1577 by Thomas Warren, probably on the site of an earlier medieval building.

6 Snowshill

Snowshill is an unspoilt village and one of the most remote in the Cotswolds, lying 2½ miles south of Broadway. Located at over 274 metres above sea level on the edge of a minor escarpment overlooking the Windrush valley, its name indicates that it is a place 'where the snow lies long'. Despite this, when it was used as a location for the film *Bridget Jones's Diary* (2001), fake snow had to be used!

The village is steeped in ancient history. The surrounding area, for example, has yielded important finds from the Bronze Age period, including a collection of weapons now housed in the British Museum. From the beginning of the ninth century it is known that Kenulph, King of Mercia, gave the settlement to Winchcombe Abbey, whose flocks of sheep (up to a thousand strong) grazed the local hillsides. The abbey continued to own Snowshill until the Dissolution of the Monasteries, apart from a short period when it temporarily came under the control of an abbey at St Ebulf in Normandy.

Buildings of interest include the Snowshill Arms, which, dating from the thirteenth century, is believed to have operated as a brewery for the monks of Winchcombe Abbey. The parish church of St Barnabas also dates from the thirteenth century, although it was largely rebuilt in 1864, and includes a fine octagonal Perpendicular font and a Jacobean pulpit. However, of greatest interest is the sixteenth-century manor, now owned by the National Trust, which once formed part of the marriage dowry of Catherine Parr, King Henry VIII's sixth queen. Snowshill Manor is renowned for the eclectic collections amassed by its eccentric owner Charles Paget Wade, between 1919 and 1951. There are more than 22,000 strange and unusual objects displayed in twenty-two rooms,

View from the top of the village looking south.

ranging from historic toys, bicycles and costumes to musical instruments, model carts and even Samurai armour. Wade certainly lived up to his family motto, *Nequid pereat* ('Let nothing perish'), displayed in the entrance hall of the manor. Although many of the objects appear to be exotic and from far-flung locations, in fact they were all collected on home soil. The collections always took pride of place at the manor house. However, Wade himself opted to live in more spartan surroundings in a small cottage on the estate, while enjoying exhibiting the collections in the house to writers as diverse as Virginia Woolf, John Buchan, Graham Greene, J. B. Priestley and John Betjeman. It is also worth visiting the manor's gardens, created in the Arts and Crafts style and which include an unusual square stone dovecote dating from the seventeenth century.

Another collector associated with the village is the American industrialist Henry Ford who, greatly impressed by Cotswold architecture, bought Snowshill's forge in November 1930 and transported it brick by brick across the Atlantic to form part of his museum in Michigan. Lastly, no visit to Snowshill is complete without seeing the Cotswold lavender fields during the summer months, planted by an arable farmer who wished to diversify. The farm covers 21 hectares and includes forty different varieties of lavender, grown at 305 metres above sea level.

7 Stanway

Stanway is a village that boasts major architectural delights and lies 1½ miles north of Stanton and 4 miles north-east of Winchcombe. At the time of the *Domesday Book* it was known as Stanwege, its name deriving from 'stone way'. Although there is mention of a monastery once being located here, no trace of it remains today. However, it is likely that the present church was built on the monastery's previous site. The village was once a hive of activity with a range of predominantly milling industries taking place, from corn to cider and even paper. Stanway also lay on an old salt trading route, which led up to Hailes, running along Salters Lane.

After the Dissolution of the Monasteries, the estate transferred from Tewkesbury Abbey to the Tracy family, who built Stanway House in the 1580s on the site of the Abbot of Tewkesbury's residence, using rich golden-coloured Guiting Cotswold stone extracted from local quarries. Over time, the house transferred to their descendants, the Earls of Wemyss. Today, the family lives in the magnificent Renaissance-style gatehouse, built around 1630 by an architect from Little Barrington, Timothy Strong. One of the house's distinctive features is the scallop-shell motif derived from the Tracy coat of arms.

The gatehouse of Stanway House.

Stanway House has several interesting literary associations. James Barrie and Edith Wharton both visited, the thatched cricket pavilion in the grounds of the house being a gift Barrie made in celebration of games he played in the 1920s as captain of the Allahkabarries team. Because of his close connection with the Tracy family, another interesting link is with Dr Thomas Dover. Known as 'Quicksilver' after introducing mercury into medical practices, he was not only the grandson of Robert Dover, the founder of the Cotswold Olympick (sic) games, but also, in 1708, the sea captain who rescued Alexander Selkirk from the island of Juan Fernandez, upon whom Daniel Defoe later based *Robinson Crusoe* (1719).

Standing next to the gatehouse is the church of St Peter where Thomas Dover is buried together with members of the Tracy family. Built in the twelfth century, the church was heavily restored at the end of the nineteenth century, with one of the ancient stone coffins and other parts of the masonry now forming part of the northern section of the churchyard wall. Another impressive building, located within the grounds of Stanway House, is the fourteenth-century tithe barn once used to store grain for the Abbot of Tewkesbury. Situated at the south side of the village, of great interest is a superb bronze war memorial designed by Alexander Fisher and depicting St George slaying the dragon, one of the most striking in the whole of the Cotswolds.

Finally, of note is a unique recent addition to Stanway House – a single-jet fountain, opened in 2004, which when activated is capable of reaching 91 metres, making it the highest fountain in Britain and the highest gravity fountain in the world.

8 Hailes Abbey

The ruins of Hailes Abbey are today owned by the National Trust and managed by English Heritage and lie 2 miles north-east of Winchcombe. The abbey was founded in 1246 by Richard, Earl of Cornwall, King of the Romans and a brother of King Henry III, in fulfilment of a vow made four years earlier when Richard, returning from a Crusade in the Holy Land, was almost shipwrecked off the Scilly Isles. After being colonised by monks from Beaulieu Abbey in Hampshire, Hailes became one of the country's greatest Cistercian monasteries,

at one time owning as much as 5,252 hectares of land and 8,000 sheep. In 1270 Richard's son Edmund, Earl of Cornwall, provided the abbey with a phial said to contain sacred blood collected at the Crucifixion. Gradually, over the following centuries and assisted by Chaucer's pardoner in *The Canterbury Tales* (1476), who exclaims 'By the blode of Crist that is in Hayles', it eventually became a major centre of pilgrimage that could compete with other major sites such as Canterbury and Walsingham. During the Dissolution of the Monasteries, however, the relic was found to contain 'honey clarified and coloured with saffron'. It was also claimed that the monks had used the phial to obtain money from pilgrims by deception, since the glass phial reputedly had one opaque side and another which was transparent. After being shown the opaque side, the pilgrims were told that only those without mortal sin could see the blood of Christ. They were then able, suddenly, following payment, to see the blood!

It is claimed that the abbey's despoilers at its dissolution in 1539 were particularly brutal because of the notoriety of its fake relic. In 1542 the abbey was sold to be demolished while still leaving some of the cloisters and an assortment of foundations standing. For a while the site was used as a stone quarry, a fate that befell many monastic buildings, and some of its stone was even used to rebuild Sudeley Castle near Winchcombe. In 1543, the site and ruins had been given to Catherine Parr, King Henry VIII's last wife, and then

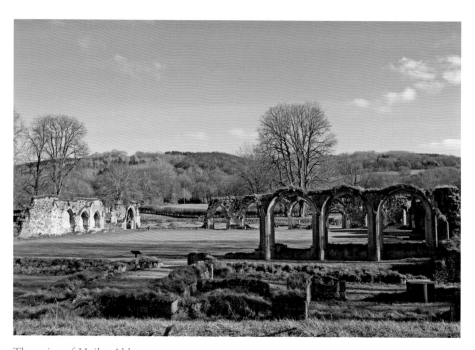

The ruins of Hailes Abbey.

eventually, in 1937, after passing through the hands of various families, it was acquired by the National Trust. Today, the site contains an excellent museum where thirteenth-century roof-bosses, glazed armorial tiles and other fragments of masonry can be seen.

Close to the abbey is Hailes church, consecrated in 1175, which pre-dates the abbey, and is now all that remains of the village of Hailes. Inside, the church contains a small amount of stained glass from the abbey as well as some fine medieval wall paintings of both ecclesiastical and secular scenes, including a hunting scene, a beautiful owl and the eagle of the Earl of Cornwall, which provide echoes of the time of the founding of the abbey.

9 Winchcombe

The small historic town of Winchcombe, its Old English name *wincel cumb* meaning 'valley with a bend', lies in the Isbourne valley 8 miles south-west of Broadway. The area is steeped in ancient history, as revealed through the nearby Neolithic long barrow of Belas Knap. Strategically well placed to centrally control access to the hills, by the eighth century it had become the capital of the kingdom of Mercia. In around AD 790, King Offa established a nunnery at Winchcombe, and eight years later his successor King Kenulf began to build a monastery on the site, which was subsequently dedicated to his son and heir St Kenelm, who was buried there after being killed in battle against the Welsh, or martyred, depending on the account, for which he was canonized. The abbey soon became a major pilgrimage site and, until the Dissolution of the Monasteries, flourished to become one of the largest landowners in the Cotswolds. The crypt of the church of St Pancras in Winchcombe has been identified as the shrine of Kenelm and his father. Winchcombe was so important that it even became the county town, albeit briefly, of its own shire, Winchcombeshire, until this was incorporated within Gloucestershire during the eleventh century.

Following the Dissolution, much of the stone from Winchcombe Abbey was used elsewhere in the town and in the building of nearby Sudeley Castle. The church of St Peter, which originated as one of three churches in the abbey and mainly dates from the fifteenth century, however, survived demolition and contains a cemented frame displaying some of the medieval tiles salvaged from

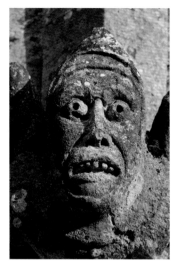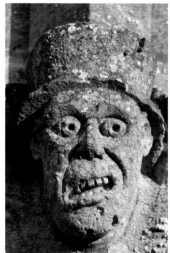

The gargoyles at St Peter's church.

the abbey. It was rebuilt in the Perpendicular style as a result of prosperity from the wool trade and today the church is renowned for its remarkable gargoyles, numbering forty and said to be modelled on real local characters from the 1460s, many of which have been given nicknames, such as 'Mad Hatter' and 'Kaiser Bill'. It also contains an altar cloth which was reputedly embroidered by Catherine of Aragon, the first wife of King Henry VIII.

As Winchcombe's wool trade declined, other industries were tried, including tobacco production, which succeeded in flourishing for at least fifty years, despite attempts by Queen Elizabeth I and King James I to ban it – on one occasion even sending in soldiers to destroy the illegal crop because of its potential to undermine West Indian traders' interests. Around the time of the illicit production of tobacco in 1614, one of Winchcombe's most famous sons Christopher Merret was born. He became a physician and accomplished natural scientist, and was not only the first to document the process of adding sugar to produce sparkling wine but was also the first to publish a list of British wild birds.

Winchcombe's fascinating past can also be appreciated through the collections of its two unique local museums. The first of these is the folk and police museum, housed within the Victorian town hall, which includes stocks with seven holes, reputedly to allow an infamous one-legged ne'er-do-well to be accommodated along with three others. The second is a museum of railway artefacts linked to the nearby heritage Gloucestershire & Warwickshire Steam Railway, displayed within an attractive Cotswold garden.

10 Sudeley Castle

Sudeley Castle is one of the grandest and most historic castles in the Cotswolds, and lies less than 1 mile south-east of Winchcombe. Although its name rather unflatteringly derives from the Old English word *scydd* ('shed') and means 'clearing with a shed', Sudeley's royal history dates back before Domesday when King Ethelred the Unready owned a Saxon manor house on this site. By the twelfth century, a castle had been built and in the thirteenth century it is thought that William de Sudeley, the son of the local lord, was one of the four knights who assassinated Thomas à Becket at Canterbury cathedral.

The earliest features of the present building date from around 1442 when Ralph Boteler, an English baron and military commander, built the present castle on the site of the previous one. The attractiveness of the castle was to be Boteler's downfall since, after King Edward IV came to the throne, the new king took ownership of the castle, accusing Boteler unfairly of treason. It is said that, as the baron was being taken away, he bitterly exclaimed, 'Sudeley Castle, thou art the traitor, not I.'

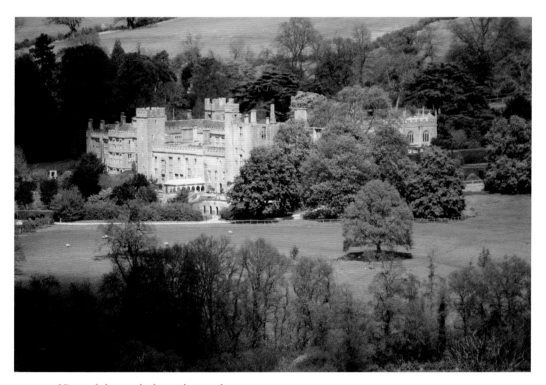

View of the castle from the south-west.

The castle assumed considerable importance during the reign of King Henry VIII. The king not only came here separately with his first two wives, Catherine of Aragon and Anne Boleyn, but also, in July 1535, visited Thomas Cromwell at nearby Winchcombe Abbey to discuss plans for the Dissolution of the Monasteries. The castle is, however, principally connected with Catherine Parr, Henry's sixth wife, who, after becoming Henry's widow, lived at Sudeley after marrying Thomas Seymour, owner of the castle from 1547 and the brother of Henry's third wife, Jane Seymour. Today, the castle's Perpendicular Gothic church, dedicated to St Mary, contains a Victorian tomb which houses Catherine's final resting place after she died giving birth to her daughter Mary Seymour in 1548. Other royal associations include the following: Queen Elizabeth I, who stayed at the castle in 1592; King Charles I, who, during the English Civil War, when the castle suffered considerable damage during skirmishes between the Royalist and Parliamentarian forces, once briefly found refuge here; and King George III who had the misfortune of falling down a broken flight of stairs when he visited the castle in 1788, only to be saved from serious injury by a housekeeper who broke his fall.

Following the end of the Civil War, after being slighted on Oliver Cromwell's orders, Sudeley was largely neglected and became derelict until it was rescued by the Worcester industrialists John and William Dent. The brothers began a programme of restoration continued by their descendants, including their niece Emma Dent, who helped to furnish the castle with period antiques and furnishings. Today, the castle is owned by Elizabeth, Lady Ashcombe, and her family, whose efforts to restore and regenerate the gardens in recent years have achieved great success.

11　Blockley

Blockley is a charming and largely unspoilt village that lies in the valley of the Blockley Brook 3 miles south-east of Chipping Campden and 3 miles north-west of Moreton-in-the-Marsh. The village has a fascinating history, dating back at least to AD 855 when Bishop Alhwine (Ealhhun) of Worcester was granted a monastery here by Burgred, the king of the Mercians and stepbrother of Kings Ethelred and Alfred of Wessex. Successive bishops developed the wool

Detail from one of the windows at St Peter and St Paul's church.

trade here, owning as many as 2,000 sheep, their wool being sold at Chipping Campden.

At the time of the *Domesday Book*, the village boasted as many as twelve corn mills, all of which were powered by the Blockley Brook. Later, these were converted for silk production, especially for the Coventry ribbon trade, which helped to alleviate the effects of the decline of the woollen industry on the village. However, by 1885 its silk industry, at its height employing over 800 workers in eight mills, was decimated by foreign competition following the removal of the levy on imported silk in 1860. Nevertheless, the village continued to reinvent itself, its mills being subsequently used for diverse other industries, from wood-sawing to piano production, and, in keeping with its reputation of moving with the times, it is claimed around 1885 that it was the first village in the country to benefit from electricity, when Lord Edward Spencer-Churchill utilised the water wheel from an old silk mill to generate enough power to light his home at Dovedale House, the church and a shop.

Among its notable inhabitants were John Rushout, the 2nd Lord Northwick, who once sailed with Lord Nelson and also built the Five Mile Drive (an attractive section of the A44 road above the village) and the millenarian (believing in a radical transformation of society) prophetess Joanna Southcott, who for most of the last ten years of her life lived at Rock Cottage at the south-western end of the High Street. Southcott was at one time quite famous as an

early women's rights and racial justice campaigner, even being referenced by Charles Dickens at the beginning of *A Tale of Two Cities* (1859). However, she was also a controversial figure, claiming that not only was she the fulfilment of the Book of Revelation prophecy concerning a woman clothed with the sun, but also that she would give birth, at the age of sixty-four, to the new Messiah. In reality, she died without giving birth, although she did marry John Smith, the owner of Rock Cottage, shortly before her death in 1814.

Places of interest within the village include the church of St Peter and St Paul, recently used as a location for the *Father Brown* television series, and Mill Dene gardens. The church tower, originally dating back to about 1180, is modelled on Chipping Campden's and dates from 1725. Inside the church are many interesting memorials as well as a Jacobean pulpit. At the southern edge of the village are Mill Dene gardens, one of the most interesting in the Cotswolds. Extending across 1 hectare, this Royal Horticultural Society partner garden is attractively set around the foundations of one of the mills which existed at the time of Domesday.

12 Moreton-in-Marsh

Moreton-in-Marsh is a good example of a late Cotswold market town and lies at the top of the Evenlode valley on the intersection between the Roman Fosse Way and the road from Oxford to Evesham, 4 miles south-east of Blockley. Although not marshy today, it is thought that the town's original name of Moreton Henmarsh once referred to a settlement founded upon moorland where wild birds once nested. By the first century AD, the Romans had established a camp here, but it was not until 1226, after the lord of the manor, the Abbot of Westminster, was granted a charter to hold a weekly market here, that it started to develop as an important market town. Later, in the late eighteenth and early nineteenth centuries, it became an important coaching halt prior to the construction of the Oxford to Worcester railway line in 1853, as well as an important centre for the linen-weaving industry, following the decline of the wool trade.

Much of its history can be appreciated along its broad high street, which lies 1 metre above the remains of the Fosse Way. One of its oldest buildings

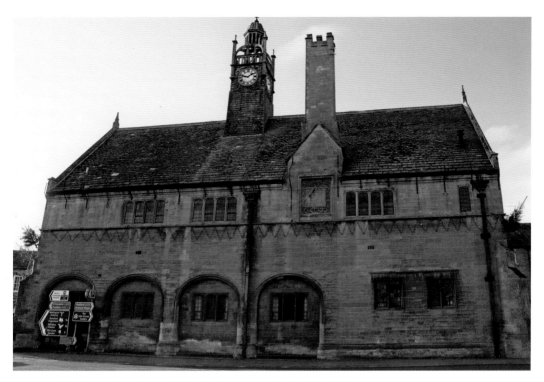

The impressive Town Hall, also known as Redesdale Hall.

is the Curfew Tower, which, apart from once being used as a local prison, still contains a curfew bell dated 1633. It was tolled twice daily between 1633 and 1860, following an unusual bequest from Sir Robert Fry, who was once unable to find his way home after returning from London on horseback in the fog. In gratitude for the ringing of the curfew bell, which eventually helped him to find his way home, he left a generous endowment to allow the clock in the tower to be wound, and the bell to be rung, twice daily.

Located on an island in the middle of High Street is the impressive Town Hall, also known as the Redesdale Hall, which was built in 1887 and named after the Redesdale family who were benefactors to the town. Lord Redesdale lived at nearby Batsford House. His six famous daughters became the celebrated Mitford sisters, some of whom became well-known for their aristocratic lifestyles and controversial adherence to communism or fascism. Originally, the ground-floor arches were open and used as a covered market place while the upper floors were regularly used as a magistrate's court. A painting of the hall by L. S. Lowry, who painted numerous Cotswold scenes during the 1940s, was bought by Elton John after he visited the town in 1972 in celebration of the launch of his Rocket record company.

Other buildings of interest include the White Hart Royal Hotel, where King Charles I once stayed during the English Civil War; the Manor House Hotel, which dates back to 1545; and the Bell Inn, which, it is claimed, provided J. R. R. Tolkien with the inspiration for The Prancing Pony, Middle Earth's inn from *The Lord of the Rings* (1954). Also of note is the church of St David's, originally a chapel-of-ease for Bourton-on-the-Hill, which was largely rebuilt in 1848. The churchyard used to contain one of the strangest epitaphs in the Cotswolds:

> Here lie the bones of Richard Lawton,
> Whose death, alas, was strangely brought on:
> Trying one day his corns to mow off,
> The razor slipped and cut his toe off;
> His toe, or rather what it grew to,
> An inflammation quickly flew to,
> Which took, alas, to mortifying,
> And was the cause of Richard's dying.

13 The Rollright Stones

The Rollright Stones, owned today by English Heritage, lie 3 miles north-west of Chipping Norton and are the most striking and unusual prehistoric landmark in the Cotswolds. The name Rollright derives from the Old English *Hrolla-landriht* indicating that land was once held here by a Saxon called Hrolla. The stones consist of three separate monuments constructed from local oolitic limestone: a 30-metre wide stone circle with seventy-seven stones, known as the 'King's Men'; a single 2.4-metres high monolith, standing nearby, known as the 'King Stone'; and, approximately one quarter of a mile to the south-east, a group of five stones, known as the 'Whispering Knights'.

Each of the monuments, built at different periods, is distinct in their design and purpose. The 'King's Men' stone circle probably dates from the late Neolithic period and was used for communal ceremonies. The stones, once numbering 105 in total, are heavily pitted and contain many lichens, some of which are 400–800 years old. They also have similarities with equivalent stone circles located in the Lake District, implying that a trade route might once have

operated between the two regions. The 'King Stone' was probably erected about 1800–1500 BC to mark a Bronze Age cemetery. Its unusual shape, which some say resembles a seal balancing a ball on its nose, has partly been shaped by nineteenth-century drovers and visitors chipping off small pieces of the rock to keep as amulets. The 'Whispering Knights' group of stones probably dates from the early or middle Neolithic period and was used to construct a burial chamber. Its name derives from the way in which they appear to huddle together, as if conspiring against their king.

The 'King's Men' stone circle.

Over the years, a number of myths and legends have arisen around the stones, the most common, first printed in 1586, telling the story of how a witch turned a king and his knights to stone. The king intended to conquer England, but when he came to the Rollrights and met a witch, reputedly Mother Shipton of Shipton-under-Wychwood, she challenged him by saying,

Seven long strides shalt thou take
And if Long Compton thou canst see,
King of England thou shalt be.

The king then went off, shouting,

Stick, stock, stone
As King of England I shall be known.

But on his seventh stride the ground rose up before him, and the witch declared,

As Long Compton thou canst not see
King of England thou shalt not be.

Rise up stick and stand still stone
For King of England thou shalt be none;
Thou and thy men hoar stones shall be
And I myself an eldern tree.

And so, the king became the 'King Stone', his men the 'King's Men' stone circle, and his scheming knights the 'Whispering Knights', while the witch is said to have turned herself into an elder tree nearby. Other stories concern the difficulty of accurately counting the stones in the stone circle, one warning that you will face death if you count the stones three times and end up with the same number each time, while another says that, should this be achieved, you will be allowed any wish!

14 Chipping Norton

Chipping Norton, known colloquially as 'Chippy', is a small market town lying 4 miles south-east of the prehistoric Rollright stones. While the town was originally built on the site of a Noman motte-and-bailey castle, only some minor earthworks in the north-west part of the town provide evidence of this today. 'Chipping' derives from the Old English word *ceapen* for market, and it was in the twelfth century that King John granted a charter allowing the town to hold a wool fair. During the Middle Ages it became a major wool-trading town as reflected in the church of St Mary's, which was built in Perpendicular style by wealthy wool merchants. Of particular interest is a hexagonal two-storey porch, one of only three in England, as well as an impressive vaulted ceiling with carved bosses and two superb alabaster table tombs of a merchant and his wife dating from 1500.

Other buildings of interest include the fifteenth-century stone buildings which surround its sloping market square; an attractive row of almshouses built in Cotswold stone, founded in 1640 by Henry Cornish, a local benefactor; and the Town Hall, dating from 1835, at a time when the town was – unusually for a town of this size – classed as a borough. On the western outskirts of the town is Bliss Mill, a former Victorian tweed mill which has recently been converted into flats. Originally built by the owner William Bliss in 1872, it stands as a reminder

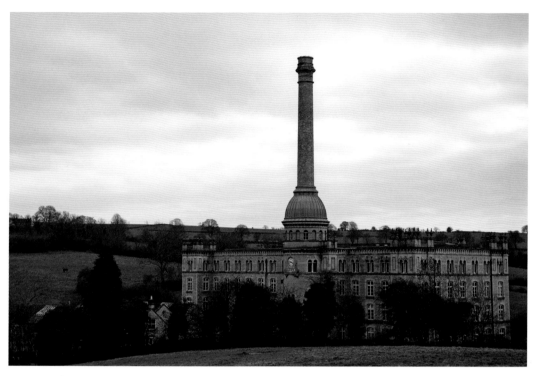

Bliss Mill, a former Victorian tweed mill.

of the prosperity brought by the textile industry during the nineteenth century and with its towering chimneystack remains one of the town's major landmarks. Much of Chipping Norton's history can be appreciated by visiting its small museum, run by the local history society. The exhibits include prehistoric and Roman artefacts, as well as displays of agricultural machinery and tools.

Interesting connections associated with the town include Winston Churchill, who, given the town's close proximity to his family home at Blenheim Palace, often chose to stay here at weekends during the Second World War in order to escape the danger of bombing raids in the south-east and the Revd Edward Stone, who discovered the active ingredient in Aspirin while living nearby. His details can be found in West Street on the site of the Hitchman Brewery, where a blue plaque commemorates his achievement. Stone was inspired after recognising that the bitter taste of willow bark might have similar therapeutic properties to the bark of the Peruvian cinchona tree, which has an equally bitter taste, and from which quinine could be extracted for treating malarial fevers. Stone's success was achieved after producing a powder from the willow bark, which he then tested on about fifty people. The powder was consistently found to be a 'powerful astringent and very efficacious in curing agues and intermitting

disorders'. He subsequently sent a letter to the President of the Royal Society in which he wrote *An Account of the Success of the Bark of the Willow in the Cure of Agues* (1763).

15 Adlestrop

Adlestrop is a small attractive village that lies 3 miles to the east of Stow-on-the-Wold in the Evenlode valley. Despite its small size, it has a long history, dating back well over a thousand years when its name derived from a Saxon farmer called Tatel. Yet its interest also resides in its links with two giants of English literature. Firstly, Jane Austen made several visits here and the village and its environs are said to have inspired certain passages in her novels. More significantly, however, the name Adlestrop was immortalised in a poem by Edward Thomas after the train in which he was travelling from Hereford to Paddington made an unscheduled stop here on 24 June 1914.

Edward Thomas's exquisite poem, which begins 'Yes. I remember Adlestrop' is quoted on a brass plaque located in a bus shelter at the entrance to the village. Appropriately, it is included on a former platform bench beneath the chocolate-and-cream-coloured station sign after both were salvaged from destruction following the station's closure in 1966 as part of the Beeching cuts. Part of the poem's continuing appeal is the atmosphere it creates of tranquillity, still experienced in the village today. Less than three years after travelling through Adlestrop, Thomas was killed in action at Arras in France and since then, his poem, published just three weeks later, has become emblematic of the devastation caused by the Great War, not least in the way it contributed to the destruction of the pastoral idyll.

The parish church of St Mary Magdalene lies at the heart of much of Adlestrop's history. It is thought to date back to the twelfth century when an earlier chapel was located on the site. However, the village referred to as Tedestrop in the *Domesday Book*, dates back as far as AD 714 when Evesham Abbey owned its manor and surrounding land. In 1553 ownership transferred to Sir Thomas Leigh, a wealthy London mercer. Subsequently, the Leigh family built a new manor house that they developed further during the 1770s, converting it into a Gothic mansion and embellishing its grounds with a water

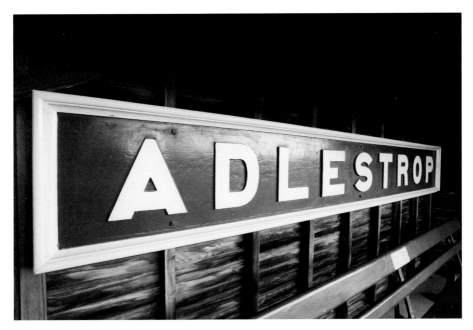

The station sign which helped to inspire Edward Thomas.

garden. Now known as Adlestrop Park, it is visible from behind the church but is not open to the public.

The church also provides an important link with Jane Austen, since her cousin the Revd Thomas Leigh was the church rector there for fifty-one years and the church itself contains many memorials dedicated to the Leigh family. She visited her cousin at Adlestrop House, then the handsome rectory located opposite the church, on several occasions between 1794 and 1806. It was probably here that she learned about the many intrigues that formed part of the Leigh family's history, later using some as plot lines in her novels. It was also at the rectory that Austen witnessed the eighteenth-century fad for garden improvements after the squire of Adlestrop, Henry Leigh, commissioned the landscape designer Humphry Repton to modernise the rectory garden for his cousin. While there is no documented record of her reaction to these changes, following her tour of the remodelled garden it is thought that her disparaging description of an 'improved garden' in *Mansfield Park* (1814), which also includes a reference to Repton, was inspired by this experience.

The area abounds in much additional historical interest, including Chastleton House, the Jacobean country house built between 1607 and 1612, accessible via a path that leads over Adlestrop Hill, and the estate at Daylesford, once owned by the statesman Warren Hastings, within walking distance of the village.

16 Stow-on-the-Wold

Stow-on-the-Wold, originally known as Stow St Edward or Edwardstow after the town's patron saint, lies about 244 metres above sea level and is the highest town in the Cotswolds. Its exposed location is reflected in the local rhyme, 'Stow on the Wold, where the winds blow cold'. Located at the junction of a number of major roads, among which is the Roman Fosse Way, the town has acted over the years as an important and convenient meeting place within the Cotswolds as well as a natural site for a market. In 1107 King Henry I granted a charter to the Abbot of Evesham, who then owned the estate, to hold a weekly market here. Fairs were also granted by royal charter from 1330, at which both sheep and horses were sold. The bi-annual horse fair still takes place today. Over time, Stow became one of the most flourishing wool markets in the country, and by

The town cross.

the time the writer Daniel Defoe visited the town in the eighteenth century he recorded that as many as 20,000 sheep were being sold in the market square in just one day.

At the centre of the town is the spacious market square. Most of the buildings located here date from the eighteenth and nineteenth centuries, including St Edward's Hall, now the local library, built in the Gothic Revival style in 1878 and formerly a favourite place for tethering horses prior to the arrival of motorised transport. Radiating from the square are narrow walled alleyways, known as 'turres', through which flocks of sheep were once herded to and from the market. Also located in the square is the town cross, the base of which is medieval in origin.

A plaque by the town cross records the significant English Civil War battle that took place here on 21 March 1646, leading to the end of the Royalist occupation of Oxford, when 200 Royalists under the command of Sir Jacob Astley were slaughtered in the square and 1,500 prisoners incarcerated overnight in St Edward's church. Such was the bloodshed, it is claimed, that ducks were seen swimming in the blood, giving rise to the name of nearby Digbeth Street, which derives from 'duck bath'. Following its use as a prison, the parish church was restored in the late seventeenth century and again in Victorian times. The churchyard still contains a few graves from Stow's wealthy wool merchants and a stone set in the floor within the church records a Royalist soldier from a local family, Captain Keyte, who died in the battle. About a mile to the north of the town a stone records the site of the commencement of the battle, with the Royalists being driven back into the town where the battle culminated. With his last hope gone, King Charles I fled his capital of Oxford for Scotland, after which he was handed over to Parliament by the Scots.

Other buildings of interest include the following: St Edward's House, with its attractive early eighteenth-century facade; the Crooked House, which probably dates from 1450 and leans as a result of poor foundations; and the Royalist Hotel, at the corner of Sheep Street, which, dating back to Saxon origins, has been validated by *The Guinness Book of Records* (1995) as the oldest inn in England. In fact, it was built in AD 987 by Aethelmar, Duke of Cornwall, and contains a medieval fireplace with marks said to ward off witches' spells. The building has been used as a hospice, a religious house, a private house and an inn. In the medieval period, the inn was called The Eagle and Child, the name being inspired by the local legend of a child who was adopted after being found in an eagle's nest.

17 Naunton

Naunton, or Niwetone, meaning 'new town', as it was called in the *Domesday Book*, lies in the upper Windrush valley 5 miles west of Stow-on-the-Wold. It is thought that this so-called 'new' village was originally established in Saxon times after the River Windrush burst its banks and displaced the inhabitants of nearby Harford, although a local legend insists that it was really one of Satan's devils who was responsible for building its first cottage after he crash-landed there with a broken wing! Evidence of Naunton's early Saxon origins was revealed as recently as 1878 through a small Saxon cross, discovered when the porch of St Andrew's church was being built. The cross has now been relocated into the north wall of the nave.

The church itself dates from the twelfth century and includes a fifteenth-century tower with two sundials, one of which is circular and contains the inscription *Lux Umbra Dei* ('light is the shadow of God') and a square one dated 1748. Most of the church was rebuilt in the fourteenth century. Inside, it contains a richly carved pulpit, dating from around 1400, and many interesting memorials, including one near the altar recording that the father of Ambrose Oldys was 'barborously murthered by ye rebells' during the English Civil War

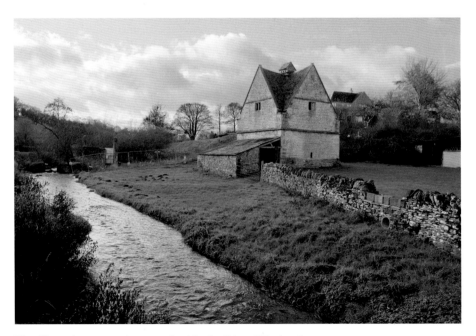

The fifteenth-century dovecote beside the River Windrush.

in 1645. Also here is a brass plate that commemorates Clement Barksdale, who became Naunton's rector in 1660 and was also widely recognised as a poet – his *Nympha Libethris*, or *The Cotswold Muse* (1651) being his best-known work.

Another building of particular interest is the gabled Cromwell House at the east end of the village, constructed around 1600 and probably the oldest house in Naunton, so called because it belonged to Richard Aylworth, a staunch Parliamentarian who showed his support for Oliver Cromwell by fighting against the Royalist forces at Stow-on-the-Wold in 1644. Also of note, located close to the River Windrush, is a fine square four-gabled dovecote thought to date from the fifteenth century although, to judge from its architectural style, more likely to be from the early 1600s. Dovecotes used to be an important feature of manorial estates, not only providing a source of luxurious meat but also a high-quality fertilizer from the pigeons' guano. However, between 1794 and 1918 when the price of corn soared, in order to reduce the loss of grain due to the birds' depredations, many dovecotes either fell into disuse or were converted to other uses. In Naunton's case, given that it was located close to a river, the dovecote was converted into a watermill and used for grinding corn for animal feeds. Today, the dovecote that originally boasted as many as 1,175 nest holes is looked after by a local conservation society which has set up a sponsorship scheme for the 903 open nest holes that still exist.

Given Naunton's idyllic charm today, it may be surprising to realise that much of its prosperity was originally based on quarrying. At one time as many as 30,000 stone roofing slates, many of which were destined for the Oxford colleges, were extracted weekly from its quarries by a hundred-man-strong workforce. Today, its quarrying heritage is revealed here and there with glimpses of a few fossils that can be seen adorning gardens and window sills throughout the village.

18 The Slaughters (Upper Slaughter and Lower Slaughter)

Upper and Lower Slaughter are two attractive villages greatly praised by J. B. Priestley in the seminal travelogue *English Journey* (1933), which lie on the River Eye less than a mile apart, approximately 2 miles north of Bourton-on-the-Water. There is some uncertainty about the derivation of the word 'Slaughter'.

Although it is often said to be derived from *slohtre*, the Old English word for 'muddy place', others claim that the name refers to 'a place of the sloe trees'. However, it is also possible that the name originated from a Norman landowner called Philip de Sloitre who lived in the area. Whichever is true, it does not refer to anything more sinister.

Although linked by name, the two villages are different in some respects. In medieval times, Lower Slaughter appears to have assumed greater importance, since, when the parishes in the local area were governed by the Slaughter hundred, it was in Lower Slaughter that from the fourteenth to the seventeenth centuries a court regularly sat hearing cases such as those of trespass, assault, dower and covenant. Although today Lower Slaughter is the smaller of the two villages, it is generally considered the more attractive because of its low miniature footbridges crossing the Eye to the fronts of attractive cottages. Of particular interest here is the manor house, now a hotel, built around 1650 by the famous Cotswold stonemason Valentine Strong, who helped with the reconstruction of St Paul's cathedral following the Great Fire of London. There is also a sixteenth-century dovecote situated next to the manor, and a nineteenth-century watermill, still operational until the 1960s and which has now been converted into a museum that tells the history of the mill and bread making.

Upper Slaughter, on the other hand, has an attractive square as its nucleus flanked by a church and the remains of the motte and bailey of a Norman castle.

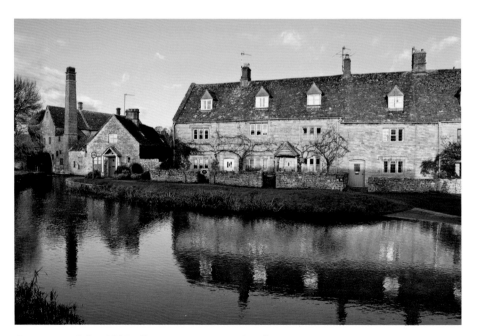

Cottages and the Old Mill Museum, Lower Slaughter.

It also has one of the finest Elizabethan manor houses in the Cotswolds, as well as another fine manor house dating from the seventeenth century, which was once a rectory but has now been converted into the Lords of the Manor hotel. There are, furthermore, some fine cottages here which were remodelled by the renowned architect Sir Edwin Lutyens in 1906.

In the church of St Peter, parts of which date back to the twelfth century, is an impressive mortuary chapel funded by public subscription in 1854 for the Revd Francis Witts. Witts is best known as the author of *The Diary of a Cotswold Parson*, which recorded life in the surrounding area between 1820 and 1852. An edited version of his diary, which was published in 1978, provides a fascinating account and interesting insights, particularly because Witts was a man of many parts: not just a rector but also a magistrate, horseman and the lord of the manor after he inherited the manor house in 1808. The church also contains a plaque which gives thanks for the fact that, almost uniquely, while sixty-one men from the village joined the armed forces to fight during both world wars, not a single one was killed.

19 Bourton-on-the-Water

The picturesque village of Bourton-on-the-Water, sometimes referred to as 'the Venice of the Cotswolds' because of the number of small, low-arched stone bridges that crisscross the River Windrush, lies 2 miles south of Lower Slaughter. Bourton's history dates back to the Iron Age when a hill fort existed at nearby Salmonsbury Camp, where a hoard of 140 currency bars was once discovered during the nineteenth century. In fact, Bourton's name derives from the Old English *borh-tun* and refers to the hill fort and river 'Burchtun' (AD 714). During Roman times it developed into a strategic outpost along one of the most important ancient highways, the inscription on Bourton bridge, rebuilt in 1806, proclaiming that the 'Fosseway has passed here since Roman times'.

In Medieval times the village prospered considerably due to the wool trade. Even flocks of sheep belonging to the Abbey of Westminster were once grazed around Bourton. However, while many Cotswold towns and villages developed into centres for weaving and textile manufacture, especially during the Industrial Revolution, Bourton largely remained an agricultural centre.

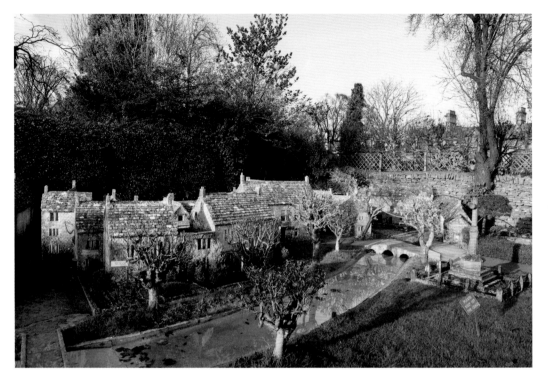

The model village, 'the one-ninth wonder of the world'.

Although its good communication links ensured that it prospered, Bourton never developed as a market centre like some of its neighbours. Consequently, today it appears relatively untouched by modernising influences apart from some commercialisation from its tourism industry – and this is part of its unique charm.

In the centre of the village is a wealth of seventeenth- and eighteenth-century buildings as well as Mill Bridge, its earliest surviving stone bridge, built in 1654 to replace one of the previous fords used to cross the river. Also located here is the church of St Lawrence, which was rebuilt during Georgian and Victorian times on the site of a Norman church and which incorporates an unusual domed tower constructed in 1784, as well as a twelfth-century crypt once linked via a tunnel to the manor house, originally used as a residence by the Abbot of Evesham. Next to the church is Glebe House, the former rectory, which, with its strikingly symmetrical three-storey facade, is one of the most impressive houses in the village.

Today, Bourton thrives from tourism, and is viewed as perhaps the most quintessential of all Cotswold villages. One of Bourton's unique attractions is its model village, opened in 1937 and amusingly described as 'the one-ninth wonder of the world', referring to the scale used to design and construct it. Located

behind the Old New Inn, it was built by the landlord with the help of six local craftsmen using authentic local materials to accurately depict how the village looked during the 1930s, even down to the detail of a revolving mill wheel on its own River Windrush and the sound of the choir singing in the church. It also incorporates a model of the model village itself. Also of interest is the Cotswold Motoring Museum and Toy Collection, established in 1978 in a converted eighteenth-century mill and which displays thousands of items illustrating the history of motoring in the twentieth century.

20 Cheltenham

Cheltenham is often described as the centre for the Cotswolds and lies 7 miles south-west of Winchcombe, overlooked by Cleeve Hill in the north-east – which, at 330 metres, is the highest point in the Cotswolds – and Leckhampton Hill to the south. Iron Age forts existed on both these hills and a Neolithic long barrow (*c.* 4,000–2,000 BC) was reputedly excavated in the town in 1832. However, the first recorded mention of Cheltenham was in AD 803 when it was known as *Celtan hom*, possibly deriving from 'well-watered valley [hamm] of (the hill called) *Cilta* or *Celta*'. By the sixteenth century, Cheltenham had developed along one long thoroughfare, the antiquarian John Leland referring to it as Cheltenham Street and describing it as 'a longe toune havynge a market'.

From 1718, Cheltenham gradually developed as a spa resort after mineral wells were discovered on farmland, reputedly from 'pidgeons pecking at the calcareous particles for the digestion of their food'. Although Daniel Defoe predicted in the late 1720s, 'The mineral waters lately discovered at Cheltenham ... are what will make this place more and more remarkable, and frequented,' the turning point in the town's fortunes only came in 1788 following a five-week visit by King George III, after which, to quote the diarist and novelist Fanny Burney, he 'declared the Cheltenham waters were admirable friends to the constitution, by bringing disorders out of the habit'. The town's popularity gained momentum after 1800, its population increasing four-fold between 1801 and 1821, and by the middle of the nineteenth century its importance can be gauged from the fact that, in 1854, it could boast the installation of pillar letter boxes eight months before London. Much of the Cotswold stone used to build

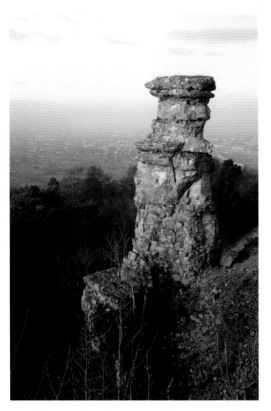

The Devil's Chimney, Leckhampton Hill.

the Georgian spa came from quarries on Leckhampton Hill, which also produced one of the town's most distinctive landmarks, the so-called 'Devil's Chimney', a feature left behind from the quarrying.

The fashion of drinking spa water began a steady decline from the 1830s onwards, and by the 1850s a gradual shift was taking place from pleasure-seeking at the spa towards evangelical preaching and learning as Cheltenham started to reinvent itself as an important centre for religion and education. Today, the town's wealth of churches and chapels, as well as its world-class educational institutions such as Cheltenham Ladies' College, bear witness to this. Later, the town also developed itself as a centre for sport, particularly horse-racing and cricket, its first Gold Cup race taking place as far back as 1815 and the first cricket festival being held at Cheltenham College in 1872, at which W. G. Grace played in the first match of the first festival and took twelve wickets for Gloucestershire against Surrey.

Much of Cheltenham's historical and cultural heritage can be appreciated through the medieval Cheltenham Minster (St Mary's); its wealth of Regency buildings, including the dome-shaped Pittville Pump Room; and its outstanding museum and art gallery called The Wilson, which contains a world-famous Arts and Crafts Movement collection inspired by William Morris. Additionally, displays featuring Cheltenham-born Antarctic explorer Edward Wilson, who perished with Captain Scott at the South Pole in 1912, can be seen. Other unique buildings include the Regency terrace-house, now a museum, where Gustav Holst, the composer of *The Planets* (1914–16), was born, and 10 St James' Square, a 'tall, old-fashioned villa, built in the most approved doll's house style of architecture', where the poet Alfred Lord Tennyson lived from 1846 to 1850. There he wrote part of *In Memoriam* (1849), the stanzas that commence 'Calm and deep peace on this high wold', said to be a description of the Cotswolds.

West Cotswolds

21 Brimpsfield

Brimpsfield is a small attractive village with an interesting history that lies 2 miles south of Birdlip, occupying a fairly isolated position near the place where the River Frome rises. At the time of the *Domesday Book*, when it was known as Brimesfelde, it belonged to Osbern Giffard, the name Giffard deriving from the early Norman French word for a person with fat cheeks and a double chin. Famous as one of the knights who fought with William the Conqueror at the Battle of Hastings, Giffard subsequently built a castle at Brimpsfield, which featured a large central keep and four towers on the site of a former Saxon fortress.

By 1322, however, the Giffards had cut their allegiance to the reigning monarch King Edward II and, along with other barons, rebelled against him, only to suffer a crushing defeat at the Battle of Boroughbridge. John Giffard was taken prisoner at the battle and later hanged, drawn and quartered for high treason at Gloucester. Following the defeat, Brimpsfield Castle was completely destroyed in 1327 on the orders of the king, local tradition claiming that he ordered that 'not one stone should henceforth stand one upon the other'. While today there is only a moat and some impressive earthworks marking the site of the castle, much of the stone from the castle is still contained in the cottages and walls of the village, including in the magnificent seventeenth-century Brimpsfield House, not open to the public, which has fragments of stone chevron decoration from the castle embedded in its west wall. There are also some finely carved thirteenth-century stone heads, believed to originate from a chapel within the castle wall, and which are now on display at Gloucester museum.

Next to the site of the castle is the parish church of St Michael's. Originally built

View close by the village green.

by the Giffards, it was later given to the abbot of a Benedictine convent at Fontenay in Normandy, who established a small priory here. The church itself contains a large stone coffin lid with a sword in relief, which is believed to be a Giffard monument. During the last 800 years of its history, the centre of gravity of the village has shifted slightly to the west, now leaving the church and the site of the castle rather isolated. The village itself, although of great importance early on, has remained small in scale. Although an ancient market was established here during medieval times, given the relatively isolated position of the village it did not flourish as much as some other villages and towns, which were able to take advantage of nearby important trading routes. Despite this, Brimpsfield remains one of the Cotswolds' hidden gems.

22 Painswick

Painswick is a large historic village, often referred to as 'the Queen of the Cotswolds' because of its fine buildings of silver-grey limestone, and lies 10

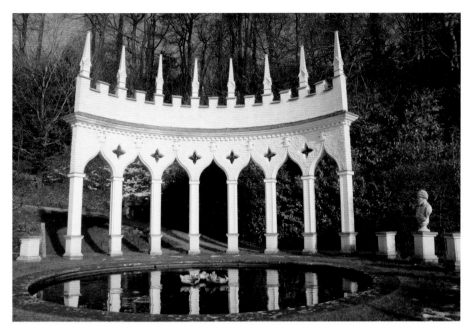

The Exedra at Painswick Rococo Garden.

miles south-west of Cheltenham. Its origins date back to prehistoric times, as evidenced by the remains of an Iron Age hill fort built on the top of nearby Painswick Beacon. At the time of the *Domesday Book*, it was called Wiche, meaning dairy farm, but by 1237 had become known as Painswik, the 'Pain' prefix having derived from the Christian name of an earlier lord of the manor, Pain Fitzjohn. During the Middle Ages the village flourished in the wool trade and between the sixteenth and eighteenth centuries its prosperity continued with the cloth trade, the reliable, fast-flowing Painswick stream being used to power the fulling mills. By 1820 there were as many as thirty mills in operation, originally established by a colony of Flemish weavers who settled here during the sixteenth century.

Today, much of Painswick's old wool and cloth heritage can still be discerned through some of its buildings. The fourteenth-century houses in Bisley Street, for example, still include two original packhorse entrances wide enough for donkeys and pack horses to pass through laden with wool from the local mills. Another noticeable feature of some of the buildings is the inclusion of south-facing attic rooms, once used as weavers' workshops. The wealth and prosperity of the village can be appreciated in buildings such as the Falcon Hotel, which, to the rear, boasts the oldest bowling green in England, established in 1554, as well as in other unusual properties such as Painswick House, about half a mile to the

north, with its magnificent example of a rare restored Rococo garden, dating from the early part of the eighteenth century.

Taking centre-stage in Painswick is the church of St Mary, which was originally built in the eleventh century and was extended in the Perpendicular style in around 1480. In 1632 its impressive and gracious spire, which rises 53 metres, was added. Just over ten years later during the English Civil War, the church sustained some damage from cannon shot, still visible on the tower today, after the village was initially occupied by the Parliamentarian forces and then recaptured by the Royalists. Evidence from the conflict can also be seen inside the church on one of the pillars where one of the Parliamentary prisoners, Richard Foot, inscribed the following words from Spenser's *Faerie Queen*: 'Be bold, be bold, but not to [sic] bold'. In the churchyard, which has sometimes been described as the grandest in the country, there is a magnificent collection of stone table tombs, dating from the seventeenth and eighteenth centuries – another example of Painswick's golden age as a cloth town – as well as other interesting graves, including those of the Victorian poet Sydney Dobell and John Parker. The latter died suddenly in 1799, aged fifty-six. His memorial explains that

> As through the field he walked alone,
> By chance he met grim Death,
> Who with his dart did strike his heart,
> And robbed him of his breath.

The churchyard is also famous for its ninety-nine yew trees which were said to be planted around 1792, the legend being that the Devil brings death to the hundredth if another is planted.

23 Slad

Slad is a small picturesque village that lies in a narrow valley 2 miles north-east of Stroud. The name derives from the Saxon 'Slade' meaning a slip of ground. In its more recent history Slad has become synonymous with the poet and writer Laurie Lee after he put the village on the literary map following publication of

his semi-autobiographical novel *Cider with Rosie* (1959). In fact, an obituary in the *Times* claimed that, apart from Thomas Hardy, no writer has ever associated himself so closely with a geographical area in Britain as Laurie Lee with the Slad valley.

All of the major landmarks in the village have an association with the writer, whether it is the church where he once sang in the choir and where there is now a window dedicated to his memory, or the school, now converted to a house, which he attended at an early age. At the social hub of the village, the sixteenth-century Woolpack Inn contains not only a series of photographs of the poet but also, lining the shelves, a small collection of vintage beer bottles that he acquired during his travels. Directly opposite the Woolpack is his burial place in the graveyard of the Holy Trinity church – 'between the pulpit and the pub' as the locals put it. The inscription on his stone proclaims simply, 'He lies in the valley he loved.'

Although *Cider with Rosie* is a beautifully poetic evocation of the end of village rural life before the advent of the modern world, much of the village today still remains unchanged from Lee's boyhood in the 1920s. You can still see many of the sites referred to in the novel, from the scene of the mysterious murder which

Laurie Lee's childhood home, Rosebank, overlooking the Slad valley.

took place at the war memorial to Steanbridge House, the former residence of Squire Jones. You can also walk in Frith Wood, now a Gloucestershire Wildlife Trust (GWT) nature reserve, known as Brith Wood in *Cider with Rosie*. But of greatest significance is the continuing existence of Rosebank, the T-shaped seventeenth-century cottage just off Steanbridge Lane, where the Lee family lived cheek by jowl with the 'Grannies in the Wainscot', Granny Wallon, or 'Er-Down-Under', and Granny Trill, or 'Er-Up-Atop, the Varmint', who were permanently at loggerheads with one another.

Lee would be delighted to know that the natural beauty of the village remains as vivid as ever, including the golden moss growing on the Cotswold stone roofs and still sparkling, as he described it, 'like crystallized honey'. He would also be heartened by the continuing protection being afforded to the Slad valley, one of the least spoiled parts of the Cotswolds. In 2014 as part of the celebrations for the centenary of his birth, a 6-mile-long circular walk called the Laurie Lee Wildlife Way was established, linking together four GWT reserves and incorporating an area of woodland, now named Laurie Lee Wood. The walk includes ten poetry posts that feature Lee's poems in front of appropriate views and vantage points, conveying an inspirational link between landscape and literature.

24 Bisley

The attractive hilltop village of Bisley, high above the Frome valley, lies 4 miles east of Stroud and has a long, fascinating history. The village was not only of importance in Neolithic times, as shown by the number of barrows spread within the locality, but also of great significance in Roman times, as evidenced by a substantial villa built nearby and the large number of altars and votive plaques found here. Some of these now form part of the British Museum's collections, indicating that Bisley was an important religious centre in Roman times. During the Saxon period, the importance of the village was further enhanced through the creation of the Bisley Hundred, one of the major parishes that were based on the largest Saxon estates at the time. In fact, until 1360 the Bisley Hundred still incorporated other significant parishes such as Stroud.

Bisley's greatest development occurred through the prosperous years of the woollen cloth industry. By 1826, a third of its population of 6,000 was employed

The Bear Inn, formerly a courthouse.

in the industry. However, the advent of mill machinery in 1838 brought with it a sudden decline and quickly decimated the cottage weaving industry, bringing mass unemployment and the necessity for relief by the Parish Poor Law authorities. From around this time came the old saying of 'Beggarly Bisley', with the response to the question, 'Where do you come from?' being 'Bisley, God help us!'

Dominating the surrounding landscape is the medieval church, mainly dating from the thirteenth century but heavily restored in the 1860s. Its lofty spire is said to have been used by German pilots during the Second World War to mark their course for bombing raids on Gloucester. In the churchyard there is a small hexagonal wellhead at which there is a rare example of a poor souls' light, where candles were once placed for the poor because they could not afford to buy their own. It is reputed to be the only one of its kind located out of doors in England and known locally as the bone-house because a priest once fell to his death in the dark here when the well was uncovered.

Next to the churchyard are the Bisley Wells, which were restored in 1863 by the vicar Thomas Keble, whose brother John helped to found the Oxford Movement and after whom Keble College was named. Since then, a well-dressing

ceremony has taken place every year on Ascension Day to bless and decorate with flowers the seven springs that make up the wells. Other buildings of interest include the Bear Inn, formerly a court house, with elegant seventeenth-century columns supporting the upper floor, and a gabled lock-up dated 1824.

It was the Revd Thomas Keble's son, another rector also called Thomas, who is attributed with instigating the Bisley boy legend, fully recounted in a separate chapter of Bram Stoker's *Famous Imposters* (1910). The legend came about after workmen discovered a stone coffin in the 1850s containing the bones of a young girl near Over Court house. Knowing that Queen Elizabeth I had once stayed here to escape from the plague in London when it was a royal hunting lodge, Keble put forward the theory that she had died there and that the frightened villagers had replaced her with a boy since they were unable to find a girl of similar age and likeness. This, he claimed, explained why Elizabeth became known as the 'virgin queen', frightened that one day the deception might be revealed!

25 Sapperton

Sapperton is a small attractive village perched high above the Frome valley and lies 4 miles west of Cirencester. Although dating back to the time of the *Domesday Book*, when it was known as Sapleton, the village gained great attention not only during the late eighteenth century, when it boasted the longest canal tunnel in England, but also at the beginning of the twentieth century, when it became intimately connected with the Arts and Crafts movement.

Much of the village's history can be gleaned through the church of St Kenelm's. Originally a Norman church, it was rebuilt in both the fourteenth century and then again around 1705. It contains some intricately carved panelling which was taken from Sapperton Hall, where incidentally King Charles I stayed in 1644, after it was demolished and the stone used to build Alfred's Hall, a folly in nearby Cirencester Park. The church also contains an impressive effigy of Sir Robert Atkyns, author of *The Ancient and Present State of Glostershire* (1712), while beneath the churchyard yews are the graves of three Arts and Crafts architects and designers: Ernest Gimson, Ernest Barnsley and his younger brother Sidney Barnsley, who, inspired by the ideals of William

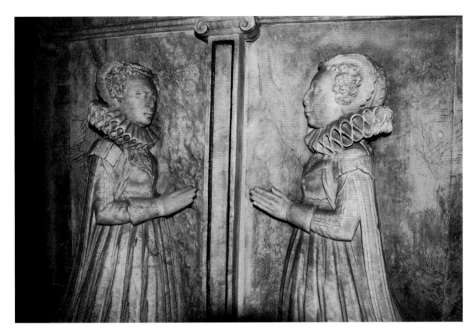

Detail from base of the Poole family memorial, St Kenelm's church.

Morris, sought to revive quality craftsmanship as a counter-reaction to the large-scale mass production of the Industrial Revolution. Their work can be appreciated in the Arts and Crafts houses that border the small village green, as well as in the village hall built by Ernest Barnsley in 1912. Also of interest is Bachelor's Court, the house where Norman Jewson, Gimson's friend and associate, lived, and where he described his life as Gimson's student in *By Chance I did Rove* (1952).

Passing beneath the village is Sapperton canal tunnel. In 1783, a highly ambitious project was begun to build a canal that would connect the rivers Thames and Severn, necessitating the construction of a 2-mile-long tunnel through the Cotswolds. Apart from King George III, who viewed the construction of the tunnel in 1788, the diarist John Byng also witnessed the difficult conditions under which this was achieved: 'Nothing cou'd be more gloomy,' he wrote, 'than thus being dragg'd into the bowels of the earth, rumbling and jumbling through mud, and over stones, with a small lighted candle in my hand,' only then to be 'enveloped in thick smoke arising from the gunpowder of the miners'. When the tunnel opened in 1789, boats typically took between four and five hours to transit through it, propelled by 'leggers' who, lying on their backs, pushed with their legs against the tunnel roof. Despite this great feat of engineering, the tunnel proved costly and difficult to maintain and the canal was eventually closed in 1911.

Another famous person associated with Sapperton is the Poet Laureate John Masefield, who moved with his wife to live there from 1933 to 1939 at Pinbury Park, a grey Cotswold stone house about a mile north of the village. This beautiful house, which dates from the seventeenth century, was also home to Robert Atkyns and the location for Gimson's workshops before they were moved to nearby Daneway House.

26 Woodchester Mansion

Woodchester Mansion is one of the most unique and enigmatic buildings in the Cotswolds and lies hidden in a steep-sided valley 6 miles south-west of Stroud. The village of Woodchester itself is rich in ancient history, not only being the location of two important monasteries of the Franciscan and Dominican orders, but also the place where the largest ever Roman mosaic in the country was found. Known as the Orpheus pavement, the mosaic belonged to a villa built around AD 325. It contains 1.5 million tesserae (tiles) and depicts the story of Orpheus charming wild animals with a lyre. It was discovered in the village churchyard at the end of the eighteenth century and, since the Second World War, has only been on public display on three occasions, with a layer of soil being used to protect it from the elements between viewings. A replica of the mosaic, which took ten years to construct and was previously on display at nearby Prinkash Abbey, was sold at auction in 2010 to a private collector for £75,000.

The mansion itself, which lies approximately 4 miles south-west of the village, provides fascinating insights into the construction of a Victorian house. Because it was never completed, there is a unique opportunity to see the building under construction and appreciate its underlying architectural structure. Although the building work was started in the mid-1850s, there is still considerable doubt about its original purpose. While it was commissioned by William Leigh, the son of a Liverpool merchant, it seems unlikely that he built the mansion for himself, given that he already had a commodious dwelling that had recently been enlarged and tailored to meet his needs. One of the theories, possibly supported by archival documents in the Vatican, is that the house was to be made available to Pope Pius IX should the need arise for him to seek sanctuary away from Rome. He served from 1846 to 1878 but lost the Papal States to the Italian army in 1870.

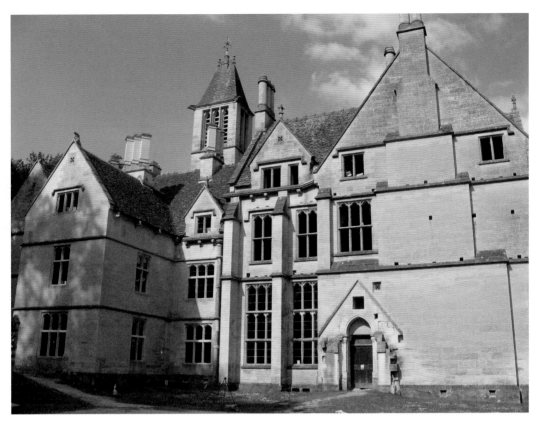

View of the mansion.

Whatever its original purpose, it was clearly meant to be hidden away and to allow the occupants to be self-sufficient, since the mansion incorporated not only a bakery and a chapel, but also a cheese-room, brewery and laundry. Another mystery is why the building was abandoned so suddenly to the extent that all tools and scaffolding were left on-site. Despite the sudden abandonment, sufficient work had been completed to illustrate the exceptional quality of its Cotswold craftsmanship. The elaborate stone carvings, particularly the spectacular gargoyles of monkeys, birds and mythical creatures, were all carried out by local craftsmen and their quality has been recognised as being equal to anything produced during the medieval period. The mansion's recent history is equally enthralling. During the Second World War, the estate's lakes were used to test the operation of combat bridges in preparation for the D-Day landings. From the 1950s, the mansion became an important site for the preservation of greater and lesser horseshoe bats, and today Woodchester's colony of bats can be viewed as part of the tour of the house.

27 Minchinhampton

Minchinhampton is a small, attractive hilltop town that lies nearly 2 miles north-east of Nailsworth on the eastern fringes of Minchinhampton Common. The town's earliest known records date back to the mid-eighth century, when King Aethelbald donated land to the church at Worcester including the extensive lands around what later became the Manor of Hampton. At the time of the *Domesday Book*, when it was known as Hantone, it contained as many as eight mills. Following the Norman Conquest, the lands were given to a convent in Caen, Normandy, and were administered by an abbess who was not only responsible for acquiring the charter around 1213 to hold a weekly market here but also, later, for obtaining its status as a town. Consequently, the town came to be called Minchin-Hampton, the word 'myncena' meaning 'of the nuns'.

By the beginning of the eighteenth century, Minchinhampton had become an important centre for not only wool and cloth, but also the quarrying of the local oolitic limestone. Today, this is still reflected in the attractive pillared Market House, built in 1698, and other fine buildings such as the Post Office dating back to the period of Queen Anne. Holy Trinity church is also of interest and, while

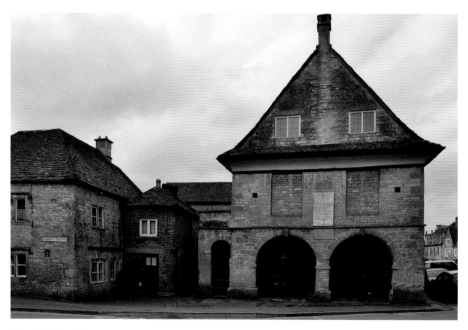

The Market House.

dating back to the twelfth century, was largely rebuilt in 1842. Its distinctive truncated spire was reduced in height in 1863 after being judged too heavy for its supporting arches.

Minchinhampton Common, the second-largest open common in the Cotswolds and now owned by the National Trust, also has a rich, fascinating history. Important as an archaeological landscape, the common is dotted with a variety of Neolithic and Bronze Age burial mounds, ancient field systems and the remains of a large Iron Age fort. On the north-western part of the common is a long barrow, known as Whitefield's Tump, the name deriving from the Methodist preacher George Whitefield, also known as the Great Awakener. Whitefield used to hold services here during the middle of the eighteenth century, sometimes to a congregation numbering as many as 12,000 people. Writing in 1743, however, it was clear that he was not always welcomed in all quarters: 'On Thursday last, I came here,' he wrote, 'and expected to be attacked, because the mob had threatened, that, if I ever came again, they would have my black gown to make aprons with.' The common was also the site of discovery in the 1900s of a 165 million-year-old fossilised dinosaur skull, now held by the Natural History Museum in London. Initially, it was thought to be an ancestor of *Ceratosaurus* but later found to be that belonging to *Proceratosaurus*, the oldest known [oldest of those known, not earliest to be known of] relative of *Tyrannosaurus rex*.

An interesting association with the town is that of the novelist Joanna Trollope, who was born in 1943 in her grandfather's rectory, now known as the Priest House. 'Being born somewhere with a strong local sense, like the Cotswolds,' she wrote, 'gave me not just a sense of rootedness, but a capacity to value landscape and weather and the rich life of smallish communities.'

28 Uley

Uley, recorded as Euuelege in the *Domesday Book* – the place name being thought to signify 'Yew-tree wood or clearing' – is a most interesting and attractive village that lies 7 miles south-west of Stroud. It is steeped in ancient history, particularly to its north along the Cotswold escarpment, where one of the largest Iron Age hill forts in the country is located. Known as Uley Bury, this 13-hectare promontory fort, protected on three sides by natural defences

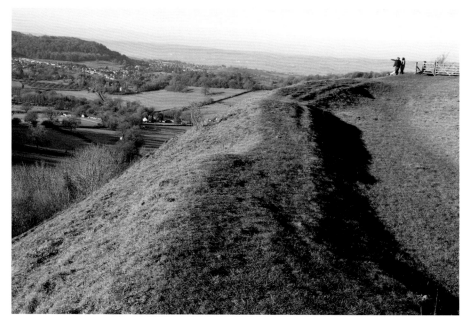

Uley Bury Iron Age hill fort.

and strengthened by a series of ditches and ramparts, was occupied from approximately 300 BC to AD 100. Although most tribesmen would have lived in the surrounding area rather than within the fort itself, there was sufficient space inside to afford protection to them and their families and livestock should the need arise. Uley Bury is also a Site of Special Scientific Interest and its strata of Jurassic limestone contain rare ammonite fossils known as *Haugia variabilis*. Located near the fort is Uley Long Barrow, also known as Hetty Pegler's tump, so named after a seventeenth-century landowner. It was here that the skeletons of fifteen to twenty Neolithic people were discovered during the nineteenth century.

The village itself features many handsome clothiers' houses reflecting the prosperity of the cloth-weaving trade, which began in the seventeenth century when John Eyles started to weave cloth imported from Spain. Uley became particularly famous for its blue cloth, often used for military uniforms, but, by the beginning of the nineteenth century, the trade had started to peter out. The closure of its Shepherd Mill in 1837, for example, laid off over 1,000 workers, most of whom subsequently sought a living in the South Wales coal mines or else chose to emigrate. The village was also once renowned for its large number of inns, today reduced to just one. However, it still boasts production of local fine ales.

The Gloucestershire historian Samuel Rudder, who was born just outside the village, wrote about Uley's fame for both cloth and ale back in 1779, noting, 'This village, tho' not large, is very populous, from a manufacture of

fine broad cloth long established here.' He continued, 'It is still carried on by several persons in a very extensive manner, and furnishes employment for the lower class of people. But idleness and debauchery are so deeply rooted in them, by means of those seminaries of vice called Alehouses, that the poor are very burthensome.'

Overlooking Uley, from near the village green and for at least 800 years, is the local parish church of St Giles rebuilt in 1857 by the well-known London architect Samuel Sanders Teulon, having already replaced earlier churches dating from the Norman and Saxon periods. Appropriately, in the space below Teulon's ornate tower several old memorial tablets were re-installed, including one to John Eyles, 'the first that ever made Spanish Cloath in this parish'. Also of interest is the grave of Roger Rutter (alias Rudder), Samuel Rudder's father, which is located in the churchyard on the south side of the chancel. His gravestone records on a brass plate the remarkable fact that the eighty-four year old had 'never eaten flesh, fish, or fowl, during the course of his long life'.

29 Dursley

Dursley is a small market town with a fascinating past and lies just over 2 miles west of Uley, sheltering against the backdrop of Stinchcombe Hill. The original settlement grew around a castle, now lost, which was built in 1153 by Roger de Berkeley, a near relative of Edward the Confessor. Thereafter, it developed into an important centre for the Cotswold wool and cloth trades. However, its association with the wool trade has not always been a proud one, as revealed through the old phrase, 'A man of Dursley', commonly used from the sixteenth to the eighteenth centuries to mean a cheat. This originated from the illegal practice, supposedly quite prevalent here, of mixing inferior quality wool among the fibre of higher-quality fleeces. By the Victorian times, however, a more refined association with the town had been recorded, that of 'Dursley lanterns', which referred to the local custom of gentlemen, when escorting their ladies home on dark nights, to walk ahead with their shirt tails showing so as to guide their way.

At the heart of the town's history is the story of the spire of St James's church, which collapsed in 1698 killing several bell-ringers and bystanders. Having just been inadequately repaired, the vibration from the celebratory peal of the bells

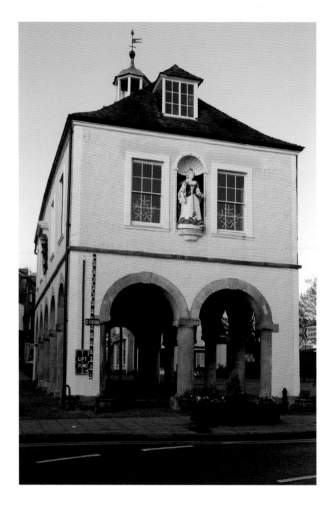

The market house with
the recessed statue of
Queen Anne.

caused the spire to crash down! When the town petitioned the king for assistance
to rebuild the tower, it was Queen Anne who granted a substantial sum. For this
reason, a statue of Queen Anne, recessed in the market house when it was built
in 1738, gazes across to the church.

In its more recent history, Dursley became a highly successful town of light
industry and manufacturing. The company of R. A. Lister, originally established
here in 1867, was still trading in Dursley under the name Lister-Petter until
2014, and specialised in manufacturing engines and agricultural machinery.
By 1936, its output of a certain type of diesel engine was the highest in the
world. In 1905 Lister acquired the locally based Dursley Pedersen Company,
manufacturers of the unique Dursley Pedersen bicycle, designed by the Danish
inventor Mikael Pedersen, which featured an unusual design of frame and
hammock-style saddle. Although Pedersen died in obscurity in Denmark in

1929, his remains were exhumed and re-interred in Dursley cemetery in 1995 in appreciation of his much-loved invention that still has its avid enthusiasts today.

Literary associations with the town include Evelyn Waugh, J. K. Rowling and, speculatively, William Shakespeare. Waugh lived for nearly two decades in the village of Stinchcombe, just 2 miles north-west from Dursley and was fearful that the town might one day expand right up to his doorstep, even instructing his wife when he was away during the Second World War that, if this happened, she should sell their property. Purely based on speculation, is the theory that William Shakespeare spent a period of his so-called 'lost years' – when little was known about his whereabouts – in Dursley. The claim is supported in his play *Richard II*, set in Gloucestershire, by a reference to the location of Berkeley Castle as being 'by yon tuft of trees', possibly indicating Shakespeare's intimate knowledge of the area. Of much greater certainty, however, is the fact that Dursley gave its name to the Dursley family in J. K. Rowling's *Harry Potter* books, the author, who was born in nearby Yate, being familiar with the town when living in Gloucestershire.

30 Berkeley

The small town of Berkeley, famous for its castle and association with Edward Jenner, the pioneer of vaccination, lies on a small hill in the Vale of Berkeley 6 miles west of Dursley, close to the River Severn. The name, first recorded as Berclea in AD 824, derives from the Old English for 'birch-tree wood or clearing'. By the Middle Ages, Berkeley had become an important port and market town, having previously developed from a large Saxon settlement. There is also possible evidence of a Roman temple once being sited here.

The castle, which has been the seat of the Berkeley family for almost 900 years, dates back to the late twelfth century and was originally gifted by King Henry II, the then Duke of Anjou, to a wealthy provost of Bristol. The castle is steeped in history and has many associations with several dynasties of English monarchs, including King John, King Henry VII, King Henry VIII, Queen Elizabeth I, King Charles I and King George I, the Prince Regent. In 1327 it was the scene of the gruesome murder of King Edward II after he was imprisoned

Inside the cell where Edward II was held and murdered.

there. Contemporary accounts claim that he was killed after a red hot poker was thrust into his posterior, supposedly to allow the concealment of any visible marks. The castle was also chosen by the barons of the west as their gathering place before departing for Runnymede to meet King John to enforce the signing of the Magna Carta. During the English Civil War, the castle was besieged by the Parliamentarians, eventually forcing the Royalists to surrender after breaching the castle wall. The castle includes many interesting paintings and antiques, including some furniture that belonged to Francis Drake, who was a regular visitor.

The town and castle also have some interesting Shakespearean connections. *Midsummer Night's Dream* is thought to have been written for the wedding of Sir Thomas Berkeley to Elizabeth Carey in February 1596. Berkeley is also mentioned in *Richard II* when Bolingbroke enquires, 'How far is it, my lord, to Berkeley now?' 'Believe me, noble lord, / I am a stranger here in Gloucestershire,' replies the Earl of Northumberland. Probably referring to the Cotswolds, he continues, 'These high wild hills and rough uneven ways / Draws out our miles, and makes them wearisome.'

In the town within walking distance of the castle is the museum, which tells the story of how Dr Edward Jenner pioneered vaccination against smallpox. Born in Berkeley in 1749, Jenner tested the local country-lore theory that people

exposed to the mild cowpox virus could not catch smallpox, one of the most feared and deadly diseases of the time. He conducted experiments to prove the theory and, despite his work initially being ridiculed, it led to the eradication of smallpox in 1980. Jenner not only completed the groundwork for the modern science of immunology but is also credited as having saved more lives than any other human being. He is buried in the local parish church of St Mary's.

31 Wotton-under-Edge

Wotton-under-Edge is an attractive market town, lying 6 miles south of Dursley, above the Severn Valley and close to the edge of the Cotswold escarpment. Known in Saxon times as Wudetun meaning 'farmstead in the wood', land was originally leased here from King Edmund I to Eadric in AD 940. During the reign of King John it is thought that the original town, then part of the Berkeley estate, was destroyed by fire, leading to it being rebuilt in 1253, when it was then granted borough status.

The town's coat of arms incorporating a stream, a sheep and two teasels, reflects its past history as a place which, for centuries, thrived on sheep rearing, wool spinning and cloth weaving, teasels once being used to raise the nap, or roughness, of the cloth. It is thought that Flemish weavers first came to Wotton in 1330 and by 1538 the antiquarian John Leland described Wotton as 'a pretty market town well occupied with clothiers'. By the early 1600s half of the town's workforce was occupied in this trade.

The parish church of St Mary the Virgin, consecrated in 1283, was built on the site of an earlier church destroyed by fire. It is predominantly Perpendicular in style and contains some exceptionally fine medieval brasses depicting Thomas, Lord Berkeley, and his wife. This Lord Berkeley, grandson of the Thomas, Lord Berkeley, who was accused of complicity in the murder of King Edward II, fought under three sovereigns, including King Henry V, with whom he served at Agincourt. Also of interest is an organ, believed to have been first played by Handel and originally given to the church by King George I in 1726 after being brought from St Martin-in-the-Fields.

Another notable building is the timber-framed Ram Inn, which, although no longer an inn, is thought to be Wotton's oldest house and was used to

WORKS OF MERCY OF AND HUGH PERRY 1638

Detail from one of the chapel's memorial windows, Perry and Dawes Almshouses.

accommodate the stonemasons and carpenters who helped with the construction of the thirteenth-century church. It also has a plaque commemorating Stephen Hopkins, one of the Pilgrim Fathers who sailed in the Mayflower in 1620. Other interesting buildings include some attractive almshouses near Church Street, funded by local benefactors Hugh Perry and Thomas Dawes, dating from 1638, which include a seventeenth-century chapel containing attractive stained-glass windows depicting Wotton's history as a wool town. Also of interest is the now privately owned Tolsey, dating from 1595, but previously used, among other things, as a courthouse and lock-up. Apart from a comical dragon weather-vane which surmounts its cupola, it also features an impressive clock commissioned in 1897 to celebrate Queen Victoria's diamond jubilee.

Among the famous people who have lived in the town, pride of place goes to Isaac Pitman, who invented his system of shorthand in 1837 when living in a house in Orchard Street. Finally, overlooking the town from the top of Wotton

Hill is one of the town's most visible landmarks, a collection of trees that replaced original nineteenth-century plantings made to commemorate the Battle of Waterloo. The trees are reputedly on the site of a beacon intended to warn the area of the arrival of the Spanish Armada in 1588.

32 Tetbury

Tetbury is a small, attractive market town located 10 miles east of Wotton-under-Edge. The town was first mentioned in a charter dated AD 681 by King Ethelred, in which he referred to Tetta's monastery. Tetbury also had a castle built by Robert of Gloucester in the middle of the twelfth century and used during the civil war between Stephen and Matilda when Malmesbury Abbey was under siege, but which no longer exists. During the Middle Ages the town prospered through the Cotswold wool trade, the influence of which lasted well into the eighteenth century. Its continuing impact was appreciated by Daniel Defoe who, after riding through the town as part of *A Tour thro' the Whole Island of Great Britain* (1724–7), commented, 'Those that see ... the Quantity of Wooll brought to the Markets of Tetbury, and other Towns ... would wonder how it was possible to be consumed, manufactured and wrought up.'

Even today, the town's link with its wool trade past lives on through its annual celebration of the Tetbury Woolsack Race, thought to have originated in the seventeenth century by young drovers showing off their strength and stamina to local women. The modern races, which have taken place since 1972, challenge the participants every spring bank holiday to run up Gumstool Hill, a street with a one-in-four gradient, while carrying a woolsack weighing 60 pounds! Also connected with the wool trade is the Market House, located at the town's centre. Built in 1655, it stands on twenty-one pillars and was originally used for wool stapling. An earlier market was held at the Chipping, a name that derives from the Old English word *ceapen* for market, which was used both for weekly markets and twice-yearly mop fairs and where labourers and domestic staff were hired for employment. From medieval times until the early nineteenth century, market-goers reached their destination by walking down the cobbled Chipping Steps.

Given Tetbury's position on the Wolds, rather than below them, where potentially it could have benefited from streams capable of powering mills, it

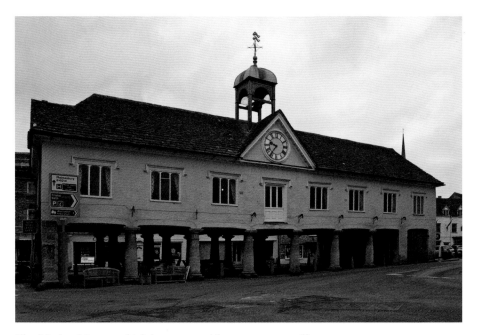

The Market House, which is supported by twenty-one pillars.

was unable to compete effectively with better-placed towns during the Industrial Revolution. Consequently, its woollen industry, largely comprising cleaning and combing the wool, started to decline, even though John West, a local Tetbury man, improved the combing process by inventing a special tool around 1710. Despite the general decline, the town maintained its prosperity through its strategic location on the intersection between two important routes: the Roman Fosse Way, running from Cirencester to Bath; and the road from Nailsworth to Malmesbury.

Also of interest are Tetbury's small museum, located in an old court house and telling the story of the history of policing in Gloucestershire since 1839, and the parish church, unusually dedicated to both St Mary the Virgin and St Mary Magdalen. Built between 1777 and 1781 on the site of an earlier church, it is a good example of Georgian Gothic architecture incorporating a spire, which, at 57 metres, is one of the highest in the country. There are also some interesting monuments, one of which includes the following enigmatic inscription:

> In a Vault underneath
> lie several of the Saunderses
> late of this parish; particulars
> the last day will disclose. Amen.

East Cotswolds

33 Chedworth

The attractive village of Chedworth lies in a tributary valley of the upper Coln 4 miles south-west of Northleach. Although Chedworth is largely synonymous with the Roman villa that lies 1 mile to the south, the village too has an interesting history, and is known to have been continuously inhabited since at least the eighth century. The oldest house in the village is the manor house, which, together with the nearby church dating to around 1100, which has a Norman tower dedicated to St Andrew, was built during the boom years of the wool trade.

However, 1491 is the key date in Chedworth's history when Elizabeth of York, King Henry VII's queen, came to visit the church after it had been recently extended, the main street being subsequently named Queen Street in her honour. Inside the church, which has a light Perpendicular interior, is a set of stone carvings which feature King Henry VII and his queen, Elizabeth; Anne Neville (née de Beauchamp), whose family owned Chedworth Manor; and Anne's husband, Richard Neville, Earl of Warwick, who became known as the 'kingmaker' after helping King Edward IV and then King Henry VI to succeed to the throne. Another interesting feature in the church is a fifteenth-century pulpit which has been carved entirely from a single block of stone.

While many of the cottages in the village date from the seventeenth and eighteenth centuries, one built in the 1600s is today missing. In 1930, it was dismantled and transported 3,000 miles across the Atlantic to form part of Henry Ford's museum at Greenfield Village at Dearborn in the State of Michigan. Ford had initially attempted to buy Arlington Row in Bibury, then, failing that, St Peter's church in Winchcombe. However, when that purchase also fell through

The stone corbels of Henry VII and Elizabeth of York at St Andrew's church.

he eventually succeeded in buying Rose Cottage in Chedworth. The logistics of transporting the 475 tons of stone, firstly via a sixty-seven-wagon train and then by ship, cost over $5,000 at 1930s value.

Although Rose Cottage was consciously removed from Chedworth's environment eighty-five years ago, another house that had lain undiscovered for centuries was earlier only discovered by chance. This was the Chedworth Roman villa, which almost never saw the light of day, since it was only in 1864 when a gamekeeper, digging out a lost ferret from a rabbit warren, first discovered fragments of mosaic and pottery. Lord Eldon, the owner of the property, then organised further excavations and subsequently built a museum to display household artefacts discovered on the site. Built in the second century AD, the villa proved to be one of the largest and most luxurious houses in Roman Britain, boasting thirty-two rooms and including mosaic floors, bath complexes and hypocausts, and is now in the care of the National Trust. An unusual part of the Roman legacy, which can still be seen at the villa and in the surrounding area, is the preponderance of European edible snails.

34 Northleach

The small attractive town of Northleach lies in the Leach valley 10 miles north-east of Cirencester, the A40 bypass to its north helping to preserve its

relatively unspoilt situation. Transport has been central throughout its history, the original settlement not only being closely located to an important crossroads on the Roman Fosse Way but also, by around AD 300, being positioned on the Salt Way when salt was carried by packhorse from Droitwich to Lechlade before being transported on to London along the River Thames. The most significant date in its history is, however, 1227, celebrated by a colourful sign in the sloping market square, when the Abbot of Gloucester was granted a charter to hold a weekly market. The town subsequently became an important wool-collecting centre as sheep from the neighbouring abbeys of Cirencester, Gloucester and Winchcombe were permitted to graze on the surrounding hills. Huge quantities of wool were exported to Europe, a practice which continued until around 1536 on commencement of the Dissolution of the Monasteries.

The town continued to flourish as a centre for sheep-rearing, particularly between 1340 and 1540, and the vast wealth accrued by the wool merchants was used to build the town's magnificent church of St Peter and St Paul in the Cotswold Perpendicular style. Inside the church, woolsacks can still be seen below the merchants' feet on some of the brass memorials, considered to be the finest in the region. In fact, woolsacks still remain a symbol of wealth and power in British traditions today, for example through the Lord Chancellor's seat in the House of Lords, which is adorned with a woolsack.

Following the cessation of the wool trade, Northleach developed in a more diversified way, attracting tradesmen such as weavers, smiths, slaters and brewers. However, by the eighteenth century not everyone was overly impressed with its physical appearance. When, for example, the diarist John Byng travelled through Northleach in 1784, he described it as 'a poor dismal place' and commented on the stone buildings, which turned black and gave it a 'monastic look'. But this comment may have arisen largely as a result

Brass memorial of a wool merchant and his wife, St Peter and St Paul's church.

of the poor weather he experienced during his visit, as the town's wonderful mix of architectural styles has normally been one of its major attractions – from late-medieval cottages to half-timbered Tudor houses.

One of the interesting buildings that has survived from that period, is the 1790 House of Correction built by the Woodchester-born prison reformer and philanthropist Sir George Onesiphorus Paul. Once considered a model prison for the care and rehabilitation of prisoners, it was even used as a blueprint for London's Pentonville prison. It currently houses the Escape to the Cotswolds visitor centre and the Rural Life Collection that displays important collections of agricultural implements and machinery as well as photographs illustrating former rural life in the Cotswolds.

To complete Northleach's unique appeal is a mechanical music museum housed in Oak House along the High Street, a former seventeenth-century wool merchant's house. Inside is a fascinating collection of antique clocks, musical boxes, barrel organs and automata that come to life through live demonstrations and include early live recordings made by Gershwin, Grieg and Rachmaninov. Finally, Northleach has been used recently as a location for the filming of the BBC adaptation of J. K. Rowling's *The Casual Vacancy*.

35 Sherborne

Sherborne, which has always been part of a large estate, is a small linear village that extends for over a mile along the valley of Sherborne Brook 4 miles east of Northleach. At the time of the *Domesday Book* it was known as Scireburne which signifies '(place at) the bright or clear stream'. In fact, the waters of the stream were crucial to Sherborne's contribution to the wool trade during the Middle Ages. By 1485 it had become the principal shearing station for Winchcombe Abbey's flocks, with several thousand sheep being brought here for shearing from the surrounding villages. The wool was then washed in the brook in preparation for its export to Flanders and other parts of Europe.

At the heart of the village is Sherborne House, now privately owned, having been recently converted into flats. Its current location is thought to be the original site of the Winchcombe abbot's summer palace. Following the Dissolution of the

The Sherborne Brook, which gave its name to the village.

Monasteries, the abbot sold the estate to the Dutton family, who built Sherborne House, subsequently rebuilt, particularly during the nineteenth century. Today, the estate and much of the village belong to the National Trust.

Standing beside Sherborne House is the church of St Mary Magdalene. While its tower and spire originally date from the fourteenth century, the rest of the church was largely rebuilt firstly between 1743 and 1776 and then around 1850 in a thirteenth-century style. Inside, it contains ornate white marble monuments to the Dutton family. One of the most interesting commemorates John Dutton. Born hunchbacked and known as 'Crump' he was described as 'master of a large fortune and owner of a mind aequall to it, noted for his great hospitality farr and neer and his charitable relief of ye poor'. During his noteworthy life he became a Member of Parliament and deputy lieutenant of the county as well as a colonel in the Royalist army. Despite this, he also won the friendship of Oliver Cromwell who allowed him to stock Sherborne's 1,700-hectare park with deer from Wychwood Forest.

Within the church is also the more modest memorial to James Bradley, who can doubtless claim to be Sherborne's most famous son. Born here in 1693, he rose to become the third Astronomer Royal in 1742, achieving recognition not only for discovering the aberration of light and the nutation of the earth's axis but also for establishing the Greenwich time line. In fact, it was the Bradley Meridian that served as zero degrees longitude for the earliest Ordnance Survey

maps of England. Other notable associations include King Edward I, who visited in 1282, and Queen Elizabeth I, who stayed at Sherborne House for a few days in 1592.

2 miles south-west from the village is Lodge Park, famous for being the only surviving seventeenth-century grandstand in the country. Originally built by 'Crump' Dutton in 1634 to fuel his passion for deer coursing, gambling and banqueting, it was converted into a house at the end of the nineteenth century. Today, it still forms part of the Sherborne estate and is owned by the National Trust.

36 Burford

The small historic town of Burford, often referred to as the gateway to the Cotswolds, lies 7 miles south-east of Sherborne in the Windrush valley. Its name derives from a 'ford by or leading to a *burh*', a *burh* being the Old English word for a fortified settlement. Although the original ford has long been replaced by a beautiful three-arched medieval bridge, Burford's strategic location at the river crossing led to its initial development as a Saxon settlement in the seventh century. Such was its importance at the intersection of major west–east and north–south routes, that in 1087 it became the first Cotswolds town to receive a charter, thereby allowing it to hold independent markets and to be granted status as a town. Today, the charter can be seen at a museum in the old Tolsey House, located on the corner of Sheep Street, where tolls were previously collected from prospective market traders.

Initially, the town prospered primarily through the wool trade but, over the centuries, it benefited from a wide range of other industries, including weaving, leather tanning, saddle-making, stonemasonry, brewing, timber production and charcoal-making from the nearby Wychwood forest. Quarrying of stone, which was used in the construction of buildings such as St Paul's cathedral and Blenheim Palace, was also important to the area. Its race course, which opened in 1621, also brought fame and wealth, and in its heyday it was second in importance only to Newmarket as a centre for horse racing. King Charles II attended the races with his mistress Nell Gwynn, and they were even inspired to name their (illegitimate) son, the Earl of Burford, after the town. The town later

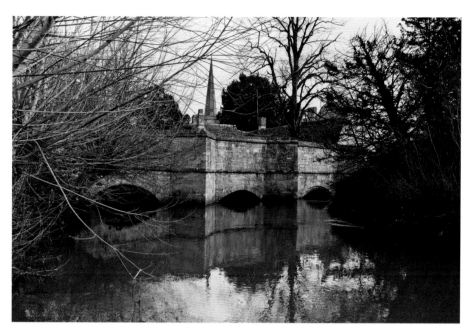

The three-arched medieval bridge, which replaced the ford.

became an important coaching town during the eighteenth and early nineteenth centuries and still contains many fine hotels and inns.

Some of Burford's most impressive buildings testify to its importance at the height of the wool trade. The church of St John the Baptist dates back to 1175 but was significantly rebuilt 300 years later and is finely decorated and of almost cathedral-like proportions. The church contains several impressive memorials, including one depicting Amazonian Indians, thought to be the earliest example of its kind in Europe. It also played an important part in Burford's history during the aftermath of the English Civil War. In May 1649, soon after the end of the hostilities, a 340-strong Parliamentarian group called the Levellers, who had mutinied against Oliver Cromwell, were captured and imprisoned in the church. Three of the leaders were shot by firing squad, the bullet holes still visible on the outside of the church. One of the prisoners recorded his incarceration by scraping the following inscription on the inside of the fourteenth-century font: 'Anthony Sedley 1649 Prisner'. In the churchyard is the grave of the novelist and poet John Meade Falkner, best known as the author of *Moonfleet* (1898). Falkner was so fond of the town that he not only wrote two poems about it but also described his love towards it as being 'a sort of fetish'. Especially taken by the charms of the church and the attractiveness of the High Street, he heavily promoted them in his Oxfordshire guidebooks.

37 Swinbrook

Swinbrook is a small, attractive village with strong historic and literary associations lying by the River Windrush 2 miles east of Burford. The village mainly comprises a small green with seventeenth- and eighteenth-century houses and cottages. However, the twelfth-century church of St Mary contains two striking wall tombs commemorating six members of the Fettiplace family, at one time the most extensive landowning family in Oxfordshire and Berkshire and who had reputedly owned property in fifteen counties. The Fettiplace mansion, which once stood between the church and the river, was demolished in 1805 after the family line died out, but the monuments provide spectacular examples of the family's former grandeur. The first monument, built in stone in 1613, depicts a trio of Tudor knights reclining stiffly on their sides, stacked almost identically one above the other, while the second, carved in marble and alabaster in 1686, also depicts three effigies arranged on top of each other, but this time the Tudor's Stuart counterparts awaiting the Day of Judgement in a more relaxed style!

The Tudor Fettiplace monument.

In the churchyard, there are many impressive examples of table-top and bale tombs, whose rounded tops symbolise wool, dating from the late seventeenth and early eighteenth centuries, contrasting strongly with the more modest gravestones commemorating four of the six Mitford sisters, the celebrated and sometimes scandalous early twentieth-century socialites. The sisters' graves comprise those of Nancy, the novelist; Unity, the Nazi; Diana, the fascist; and Pamela, the quieter one who loved rural life. The inscription on Unity's gravestone, a devotee and friend of Hitler, who eventually died from her injuries having shot herself at the outbreak of the Second World War, reads, 'Say that the struggle naught availeth.'

The family, which originally lived at Batsford Park, moved to the Jacobean Cotswold manor house at Asthall, about 1½ miles north of the village. It was this house that Nancy Mitford used as a model for her fictional Alconleigh in *The Pursuit of Love* (1945) – in which her father's habit of hunting his children with bloodhounds provides the basis for the description of 'uncle Matthew' – and *Love in a Cold Climate* (1949). The house was so cold in winter that the sponges in their bathrooms often became frozen, leading the girls to spend time together in the linen cupboard, a small room warmed by hot-water pipes. In *The Pursuit of Love*, this was fictionalised into the Hons' cupboard which was used by the Radlett children as their secret society meeting-place where they discussed 'life and death'. Family life at Asthall was also described in detail in *Hons and Rebels* (1960), Jessica Mitford's autobiography.

In 1926 Lord Redesdale, the father of the Mitfords, built a new, rather austere-looking house called Swinbrook House, a mile to the north of the village, where the family lived until 1935. Nancy disliked it so much that she dubbed it 'Swine Brook'. Until recently, the Mitfords' link to the village was maintained through Debo, the youngest of the sisters, who became the Dowager Duchess of Devonshire and is now buried at Chatsworth House. She owned the village pub, The Swan Inn, which is decorated with many pictures and artefacts linked to the Mitfords. It occupies the old mill house and was recently used as a location in the popular television series *Downton Abbey*.

38 Minster Lovell

Minster Lovell is an attractive village that lies 4 miles east of Burford. In reality, it comprises two villages, the original Old Minster located north of the River Windrush, and a settlement of bungalows to the south, built by the Chartist Land Settlement Project in 1847. Simply recorded as Minster in the *Domesday Book*, the village's suffix was not added until the thirteenth century after King Henry I granted land to the Lovell family.

At the heart of the village's history are the impressive ruins of the fifteenth-century hall, which stand in front of the church and are now in the care of English Heritage. Built by William Lovell in 1431–2, the house passed to his grandson Francis, who, as a prominent Yorkist, was one of King Richard III's

closest friends. Francis was the Lovell referred to in the ancient couplet, 'The cat, the rat and Lovell the dog, rule all England under a hog': the cat being William Catesby, Richard's Chancellor of the Exchequer; the rat Sir Richard Ratcliffe, advisor to Richard; and the hog being Richard himself, represented by his emblem of a white boar. Francis Lovell was known as 'the dog' because of his family's emblem.

Ultimately, Lovell's support for King Richard III cost him his estates as following the battle of Bosworth in 1485 when Richard was killed, Lovell suffered another defeat at the battle of Stoke after which he disappeared. Ironically, over two centuries later when a chimney was being built at Minster Lovell Hall, a secret vaulted room was discovered that contained the skeletons of a man with a pen seated at a desk and a dog at his feet. Legend has it that the skeletons belonged to Francis Lovell and his faithful hound who both perished while in hiding after his servant failed to return to feed them. However, as soon as the fragile skeletons were exposed to the air they dissolved into dust, thereby destroying any fully conclusive evidence. Whether the legend is true or not, John Buchan made use of it in his novel *The Blanket of the Dark* (1931) in which one of the characters refuses to approach Minster Lovell 'except in holy company', and Lovell's death by hunger and thirst is described in vivid detail, his agony made intolerable after gnawing at his fingertips and having 'bitten deep into his left wrist'.

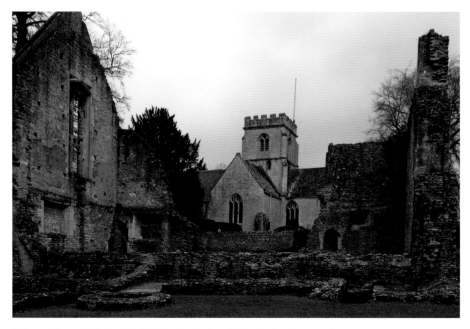

Minster Lovell Hall with St Kenelm's church in the background.

Adjacent to the hall is St Kenelm's church, named after the eighth-century boy king of Mercia, murdered by an ambitious relative and later buried in Winchcombe Abbey. The church was rebuilt in 1450 by William Lovell on the foundations of an earlier church and still contains some of its original fifteenth-century glass. Other notable buildings include the timber-framed Old Swan Hotel dating from the fifteenth century and which still has a roof of Stonesfield slates.

39 Bibury

Bibury originated as a Saxon settlement, known as Becheberie at the time of the *Domesday Book*, and lies 6 miles north-east of Cirencester. In the 1870s it was described by William Morris as 'the most beautiful village in England', his remark being inspired principally by the picturesque row of cottages known as Arlington Row, which today, as part of anti-forgery measures, has even featured as an intricate image reproduced on the inside cover of UK passports. Originally built in 1380 as a monastic shelter to house sheep owned by Osney Abbey in Oxford, it was then converted in the seventeenth century into cottages for weavers who worked at nearby Arlington Mill. The marshy ground in front of the cottages, known as Rack Isle, was used as a place where both wool, and then later cloth, were hung out to dry after being washed in the River Coln or, in the case of cloth, after being degreased at Arlington Mill. Today, both the cottages and Rack Isle are owned by the National Trust.

Another prominent landmark in the village is Bibury Court. Originally a Tudor house, it was enlarged by the landowning Sackvilles in 1633 in Jacobean-style architecture and now operates as a hotel. Running parallel to the main road is the River Coln, a tributary of the River Thames. It is an attractive feature of the village admired in 1794 by the diarist John Byng, who described it as a 'pastoral trout stream full of fish'. In fact, the river was so well suited to trout that the naturalist Arthur Severn founded a trout farm here in 1902 to stock local rivers and streams where today as many as 6 million trout are hatched each year.

Of great interest is the Saxon parish church of St Mary, thought to have been built in AD 721–43 after Bishop Wilfrith of Worcester granted the estate to Earl Leppas and his daughter Beaga, the village subsequently becoming known for a while as Beagan-byrig, or Beaga's enclosure. The church still contains a

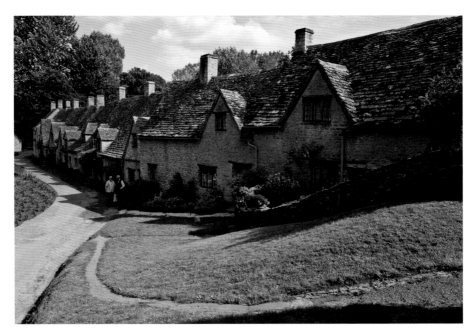

Arlington Row.

well-preserved Saxon gravestone set into the chancel wall, together with replicas of another two, the originals having been transferred to the British Museum. Outside in the churchyard, apart from a number of impressive graves of prosperous seventeenth- and eighteenth-century wool-staplers and clothiers, there is a section that is known as 'Bisley Piece'. This is associated with the remarkable story of a papal interdict that because of some cases of aggressive and drunken behaviour by the parishioners of Bisley forbade them from burying their dead within the Worcester diocese. The solution was that they carried their dead 15 miles to Bibury, the nearest place outside the diocese that would accept Bisley burials.

40 Cirencester

Cirencester is a most interesting historic market town, often referred to as the capital of the Cotswolds and situated 8 miles south-west of Bibury. The town dates back to Roman times when, in about AD 75, it was founded at the

intersection of the Fosse Way, Akeman Street and Ermin Street. At that time it was known as *Corinium Dobunnorum*, and was a major centre – second only in importance to London – for the administration of the conquered Dobunni tribe, who lived in the southern Cotswolds. Much of the town's Roman history can be appreciated through visiting the outstanding Corinium Museum, where many of the ninety mosaic floors that have been excavated within the town are on display. Another of its exhibits is a rare Roman word square, or acrostic that reads the same forwards as backwards and is thought to contain a secret Christian code. Cirencester's Roman legacy is beautifully captured by the celebrated poet U. A. Fanthorpe in 'To Cirencester from Corinium: Ave' (2004):

> We were the ones before. We hand over to you
> Chancy improbable weather, versatile limestone.
> The spirit of place was kind. We did good work:
> Theatre, magistrates' court, roads, drains, sewers,
> Desirable villas with underfloor heating.
> We did all this. You, who inherit, will understand.

In the sixth century, the Saxons destroyed the town and changed its name to *Coryn Ceastre*, which later became Cirencester. In Norman times, King Henry I founded what later became the largest Augustinian abbey in England. Sadly,

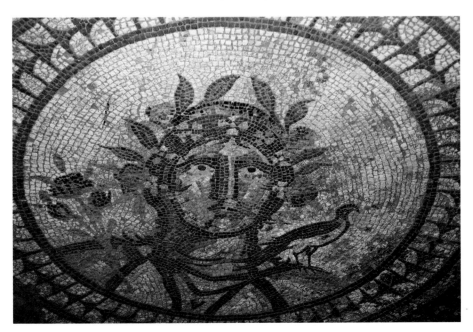

Detail from spring, part of the seasons mosaic at the Corinium Museum.

nothing of it remains following the Dissolution of the Monasteries. Nevertheless, the abbot was also rector of the parish church of St John, which, larger than some cathedrals, still survives. Dominating the Market Place, it is one of the finest of all Cotswold wool churches, many of its medieval improvements and enhancements being funded by the wool merchants commemorated in its brasses. Among the many interesting treasures inside the church is a 1535 silver-gilt cup, made for King Henry VIII's second wife Anne Boleyn, who was executed a year later for adultery. The cup includes the motif of a falcon, Anne's heraldic emblem.

During the Middle Ages, Cirencester's wool trade developed on an international scale, and there is evidence that a tradition of sheep rearing was well established by and during both Roman and Saxon times. In the fourteenth century, the Italian merchant Francesco Datini, for example, stated that 'the best wool in Europe came from the Cotswolds and the best wool in the Cotswolds came from Cirencester'.

By the eighteenth century, there were two major landowners in the town, one of which, the Bathurst family, allowed the 1,200 hectares of formal wooded parkland known as Cirencester Park to be opened to the public. Originally designed by the 1st Earl Bathurst, with help from his friend the poet Alexander Pope, who visited the park over a thirty-year period, the park was largely inspired by geometrical landscaping and conceived with the aim of making it both useful and peaceful. The park not only contains the oldest polo ground in the country, founded in 1894, but also one of the earliest mock-Gothic castles, which, although dated 1085, was constructed from around 1720 onwards. Fittingly, in recognition of Pope's help, a small classical temple was built called Pope's Seat, which became a favourite retreat for the poet.

41 Fairford

Fairford is a small attractive town situated on the River Coln about 4 miles west of Lechlade. While its history dates back to AD 500 when the Saxons established a settlement here, much of its recent development can be attributed to its importance as a coaching town on the old London to Gloucester turnpike. Today, many of its inns and hotels, some of which date back to the fifteenth century, are a visible reminder of this.

St Mary's church.

One of the town's earliest visitors was the antiquarian John Leland, who described Fairford in the sixteenth century as 'a praty, uplandish toune', which owed much of its prestige to the Tame family who built its magnificent church of St Mary. 'John Tame began the fair new chirch of Fairforde,' wrote Leland, 'and Edmund Tame finished it.' It was actually built between 1490 and 1530 and is a good example of late Perpendicular Gothic architecture, the style enabling more light to enter the building by using larger windows than previously thought possible; these were constructed using slim stone window mullions and light but strong buttresses.

John Tame and his son Edmund were both wealthy wool merchants who could employ some of the finest craftsmen. Among these was Barnard Flower, the Flemish-born glazier to King Henry VII. Today, Flower's set of twenty-eight windows depicting the Bible story from Adam and Eve to the Last Judgement, represents the only surviving intact set of medieval stained-glass windows in any British parish church. Initial anxiety about the long-term preservation of the glass, particularly because of the danger posed by Concorde's sonic boom, was soon allayed when scientists realised that more powerful vibrations in the church were being caused by the organ!

Also of great interest in the church are the carved wooden misericords in the chancel which some believe may have originated from Cirencester Abbey. Outside in the churchyard, there are many interesting ancient memorials, including one

dedicated to the memory of Valentine Strong, the famous Cotswolds stonemason, who died while working on Fairford Park in 1662. There is also a more recent one commemorating Tiddles the church cat, who perished after falling off the church roof. A young boy, who took his life after climbing onto the church roof and jumping to his death, is also commemorated through a stone grotesque.

The last words about the town's remarkable heritage perhaps belong to the political journalist William Cobbett, who not only described Fairford as 'a very pretty little market-town' when he visited in 1826, but also noted that it contained 'one of the prettiest churches in the kingdom'. In his typically acerbic style he continued, 'It was, they say, built in the reign of Henry VII; and one is naturally surprised to see that its windows of beautiful stained glass had the luck to escape not only the fangs of the ferocious "good Queen Bess"; not only the unsparing plundering minions of James I; but even the devastating ruffians of Cromwell.'

42 Lechlade

Lechlade is a small market town situated on the upper reaches of the River Thames, lying 4 miles east of Fairford on the border between the Cotswolds and the Thames valley. Its name derives from the River Leach, which joins the River Thames approximately 1 mile to the east. The town's ancient history can be traced back to 2500 BC, based on the evidence of a henge monument having once been sited here. Lechlade quickly developed as an important settlement given its advantageous location in the vicinity of several rivers including the Thames, Leach and Cole. In Roman times its prosperity was helped by its close proximity to Cirencester (Corinium), at that time second in importance only to London, and by Saxon times its importance is indicated by a large burial ground that yielded many interesting artefacts following its excavation, currently on display in Cirencester's Corinium museum.

At the time of the *Domesday Book* Lechlade was recorded as having a manor, gifted by William the Conqueror to Henry de Ferrers, one of the noblemen who fought with him at the Battle of Hastings in 1066. In 1205, one of Henry's descendants, Isabella de Ferrers, founded a nunnery, which subsequently became a priory on the site near St John's Bridge, which is now occupied by the Trout Inn. Five years later, the town was granted a market charter and, helped by its

The statue of Old Father Thames at St John's Lock.

advantageous access to river and road transport links, quickly became an important hub for the wool trade. From the sixteenth to the mid-nineteenth century, the town developed into a thriving port, further helped by the completion of the Thames and Severn canal in 1789, its commercial wharf being used to transport a wide range of goods to London. These included salt, stone, tin, coal, iron and various foodstuffs.

Dominating the town is the fifteenth-century St Lawrence's church, built on the site of an earlier thirteenth-century church from stone from a local quarry near Burford. This was the same stone used for the construction of St Paul's Cathedral and Windsor Castle. The Perpendicular-style church contains a magnificent chancel roof as well as some interesting memorial brasses, including one to John Townsend, a local wool merchant, and his wife. In 1815 the church became the subject of a poem entitled 'A Summer-Evening Churchyard' by the English Romantic poet Percy Bysshe Shelley, who was particularly impressed by the church spire, as illustrated by the following stanza:

> Thou too, aereal Pile! whose pinnacles
> Point from one shrine like pyramids of fire,
> Obeyest in silence their sweet solemn spells,
> Clothing in hues of heaven thy dim and distant spire,
> Around whose lessening and invisible height
> Gather among the stars the clouds of night.

The sixteenth-century antiquary John Leland was equally impressed by the spire, describing it 'as a pratie pyramis of stone'.

Another iconic landmark in the town is the statue of Old Father Thames. Originally built for the Great Exhibition in 1851, it was initially sited at Thames Head before being moved to St John's Lock, the highest lock on the Thames, constructed in stone in 1790 and named after the site of the nearby priory. The sculpture sums up the town well, the figure reclining next to barrels – a symbol of the cargo once transported on the river – and holding a spade, which signifies the digging of a lock to make the river navigable.

43 Kelmscott

Kelmscott was made famous by its association with the writer, designer and socialist William Morris and is a remote village situated close to the River Thames, just over 2 miles east of Lechlade. The village has early origins dating back to pre-Roman times and derives its name from 'Coenhelm's cott' and was first recorded in the thirteenth century when it numbered about thirty houses. When Morris came to Kelmscott he was immediately struck by what he described as this 'beautiful grey little hamlet' and the manor house, which he considered the 'loveliest haunt of ancient peace' and a building in such harmony with its surroundings that it looked as if it had 'grown up out of the soil'. Sheltered from the negative effects of the Industrial Revolution, Kelmscott and the wider Cotswolds provided Morris with unique inspiration, which strongly matched his idealised views of rural life. Later, in 1891, he was even inspired to establish his own printing press, which he called the Kelmscott Press.

Although the village has been largely overshadowed by the influence of Morris, it has an earlier rich and interesting history. The church of St George, for example, where William Morris and his family now lie buried, was originally built in the twelfth century and contains wall paintings that date back to the early fourteenth century and depict scenes from the Book of Genesis. The manor, a Tudor farmhouse standing adjacent to the River Thames, was originally built around 1570 by the farmer Thomas Turner. Before Morris rented it from 1871 to 1896 as his summer residence, the house had already acquired several

interesting collections, including a set of seventeenth-century Flemish tapestries depicting biblical stories. Morris became so enamoured with the house that in 1891 he even wrote a poem called 'Verses for the Bed at Kelmscott' which begins,

The wind's on the wold
And the night is a-cold,
And Thames runs chill
'Twixt mead and hill.
But kind and dear
Is the old house here
And my heart is warm
'Midst winter's harm.

Following the death of William Morris in 1896, the Kelmscott manor estate was purchased by his wife Jane in 1913 and subsequently passed on to members of the Morris family, then to the University of Oxford and finally to the Society of Antiquaries of London, who now look after it. Today, the house contains outstanding collections of Morris's possessions, his work and that of his associates, including the Pre-Raphaelite artists Dante Gabriel Rossetti and Edward Burne-Jones.

Elsewhere in the village, there are some memorial cottages, commissioned by Jane Morris in 1902 to commemorate her husband, which incorporate an Arts and Crafts-designed carving

The carving of William Morris at one of the memorial cottages.

of him by George Jack; there is also a village hall, built in Morris's memory after being commissioned by his daughter in 1934, designed by the Arts and Crafts architect Ernest Gimson.

44 Down Ampney

Down Ampney is a small attractive village best known as the birthplace of the celebrated English composer Ralph Vaughan Williams, which lies on the Ampney Brook 4 miles south-west of Fairford, not far from the infant River Thames. Central to its history is All Saints, the village church, founded by the Knights Templar in 1265 and which has an impressive fourteenth-century spire visible from miles around. The church was partly rebuilt about 1845 and in the south transept are two effigies that commemorate its founding. One represents Sir Nicholas de Valers (sometimes spelt Villiers), clad in armour, with a beast, possibly a lion, resting at his feet, and the other is thought to be his wife, Margaret Bassett, who, while her husband was away at war, is remembered for looking after the villagers' tools and agricultural implements by building a tower in the church where they could be safely stored.

Another monument of interest, which dates to 1637, commemorates Sir James Hungerford and his son Anthony, shown facing each other across a prayer desk. They were successive lords of the manor at Down Ampney House located beside the church and which, although dating from the Tudor period, was significantly altered in 1799. Beneath the pointed arches in the church are some small carved flowers, which are thought to have been painted in red as a reminder of the symptoms of the Black Death; the outbreak of the bubonic plague caused the present village to move slightly north of the church and manor house.

Commemorated in the church by a display in the bell tower is the village's association with Ralph Vaughan Williams. The composer was born at the Old Vicarage in 1872 while his father was vicar at All Saints. He lived in the village for just three years but later composed a tune for the hymn 'Come Down, O Love Divine', which he called 'Down Ampney' (1906) in tribute to his birthplace.

In front of the church are the fields once used as a Royal Air Force station. During the Second World War, aircraft operating from the airfield supported military operations for the D-Day invasion in June 1944 and later the ill-fated

The Hungerford memorial at All Saints' church.

battle of Arnhem in September of the same year. The airmen are commemorated inside the church in a stained-glass window featuring a Dakota aircraft. One of them, Flight Lieutenant David Lord, posthumously won the Victoria Cross for bravery after flying in urgent supplies to Arnhem, and every September the church holds an annual service to remember those who took part in the airborne mission. Other interesting stained-glass windows include one depicting some nautical parables. This was donated to the church by an admiral in gratitude after his ship survived stormy seas near the coast at Sebastopol during the Crimean war in 1854. Another window, which is dedicated to Ralph Vaughan Williams' father, illustrates the Resurrection Stone.

South Cotswolds

45 Malmesbury

Malmesbury is an attractive market town perched on a flat Cotswold hilltop almost completely surrounded by two branches of the River Avon and is located 5 miles south-east of Tetbury. The town claims to be the oldest borough in England, dating back officially to the fifth century, while modern archaeological excavations suggest that it is even older, probably dating back to 500 BC when the site's naturally defended position made it suitable as the location for an Iron Age fort.

The town's most historic building is its ancient Benedictine abbey, the extant part of which now forms its parish church. Founded in AD 675, the abbey soon established itself as an important centre for pilgrimage and learning. Its first abbot, Aldhelm, was later canonised, and is also known to have built the first church organ in England, a chronicler describing it as a 'mighty instrument with innumerable tones, blown with bellows'. By the tenth century King Alfred the Great had granted Malmesbury a charter and King Athelston, his grandson, the first king of all England, now buried in the abbey's grounds, subsequently made it his capital.

One of the abbey's most intriguing residents was Elmer, the eleventh-century monk said to be the first person on record to have attempted to fly. Inspired by the Greek fable of Daedalus, Elmer attached homemade wings to his arms and legs and launched himself from the abbey tower, succeeding in remaining airborne for approximately 200 yards before crashing to the ground and breaking both legs. Despite being rendered lame, he later sought to make a second flight but was forbidden from doing so by the abbot. His venture is commemorated in a modern stained-glass window installed in the abbey in 1920.

A group of apostles visited by a flying angel (detail from the abbey's Norman porch).

Another of the town's interesting associations is with Hannah Tynnoy, said to be the first person to have been killed by a tiger in Britain in 1703. She was a barmaid, who teased a circus tiger that later escaped from its cage and reputedly killed her. She lies buried in the abbey churchyard, the epitaph on her tombstone recording her sorry fate:

> In bloom of life
> She's snatched from hence
> She had not room to make defence;
> For Tyger fierce
> Took life away
> And here she lies
> In a bed of clay
> Until the Resurrection Day.

Until the Reformation, the town relied heavily on income from the abbey for its prosperity, while from 1539 it developed as a centre for weaving, wool spinning and lace making. During the nineteenth century, in particular, it was also known for the quarrying of local Cotswold stone. One of the most unusual buildings, located at the town's centre, is its fifteenth-century market cross, which also acts

as a shelter. As one chronicler recorded, 'It is curiously voulted, for poore market folkes to stande dry when rayne cummith.' Another building, the Old Bell Hotel, is said to be the oldest hotel in England and may once have formed part of a Saxon castle, demolished in 1216.

Much of the town's rich history may be appreciated through visiting its excellent small museum. Known as Athelstan Museum, its collections include a range of interesting items: examples of silver pennies, struck in Saxon times when the town had its own mint; Malmesbury lacework, once highly regarded as luxurious fashion accessories; and an important drawing by Thomas Girton (an artist greatly admired by Turner), which depicts Malmesbury's market cross.

46 Castle Combe

Castle Combe is a well-preserved medieval village often voted 'the prettiest village in England' and lies 10 miles north-east of Bath in a narrow combe or cleft-like valley cut by the River Bybrook. Today, although there are nothing more than earthworks on a hilltop golf course to the west of the village to indicate the site of the castle from which Castle Combe derived its name, this is where its history began. Originally a Roman hill fort, located close to the Fosse Way, it was later occupied by the Saxons before being rebuilt as a castle by the Normans in 1135.

During the Middle Ages, the village was established as an important centre for the wool industry, greatly helped by Sir John Fastolf, a Norfolk knight who not only became lord of the manor but was also supposedly the prototype of Shakespeare's Falstaff. It was Fastolf who built several fulling mills along the river as well as fifty cottages for the weavers. From that time the village manufactured a red-and-white cloth known as 'Castlecombe'. Fastolf even supplied it to the troops that he recruited for King Henry V's war in France. In the middle of the fifteenth century the village supported as many as seventy cloth-workers. As it developed, its prosperity became more akin to a town than a village, with both a weekly market and an annual fair taking place around its ancient market-cross, where sheep, wool and other goods were traded. In fact, the antiquary John Aubrey noted that 'the most celebrated faire in North Wiltshire for sheep is at Castle Combe, on St. George's Day (23 April), whither sheep-masters doe

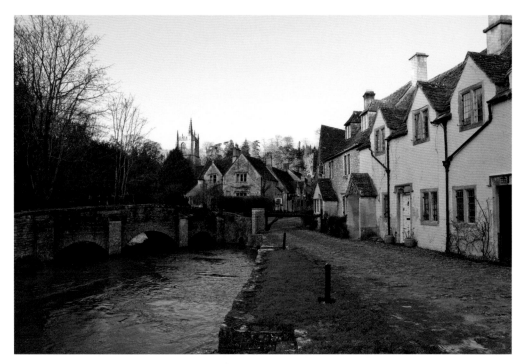

The Bybrook with old weavers' cottages along the waterfront.

come as far as from Northamptonshire'. However, by the seventeenth century the industry had started to fall into decline, particularly through competition from the more industrialised mills of Avon and Gloucestershire, but also because the small river could not cope with the larger machinery being introduced. Consequently, the last of Castle Combe's clothing mills and dye houses closed in the 1820s, with no further development taking place – thus helping to preserve its medieval past to this day.

The cloth industry is reflected in the parish church of St Andrew's, which was built at the expense of clothiers in 1434. Its tower parapet features nearly fifty stone heads and includes relief carvings of shuttles, shears and other weaving tools. It is also worth noticing in the church the example of a rare faceless medieval clock, still in use, as well as the thirteenth-century tomb of Walter de Dunstaville, complete with an effigy of the knight in chain mail, whose family owned the castle following the Norman Conquest.

In recent times, the village has been used as a favoured location for film and television dramas, from *Doctor Doolittle* in the 1960s to *War Horse* a few years ago. To the west of the village on the site of a former Royal Air Force airfield is the Castle Combe circuit, which is a venue for regular motor racing championships and other events.

47 Corsham

The handsome historic market town of Corsham lies just over 4 miles west of Chippenham. Originally dating back to Saxon times, it has sometimes been known as Corsham Regis as King Ethelred reputedly once had a villa on the site of the old manor of Corsham Court. By the time of the *Domesday Book*, it was referred to as Coseham. During medieval times the town initially started to prosper as part of the Cotswold wool trade, many Flemish weavers settling here and elsewhere in the Cotswolds from the fourteenth century, following religious persecution in their homeland. An attractive row of seventeenth-century houses along the High Street, known as the Flemish Cottages, can still be seen today.

When the wool trade started to decline during the nineteenth century, the town maintained its prosperity by quarrying the local golden-coloured Bath stone, which since the eighth century had been sourced from nearby Box village. However, it was only after the engineer Isambard Kingdom Brunel completed the 2-mile-long Box Tunnel for the Great Western Railway in 1841 that a vast expansion in quarrying took place. New underground deposits of Bath stone were suddenly discovered, and with the completion of the railway tunnel, a new means to transport the stone easily and further afield was now possible. Such great quantities of stone were transported from Corsham at that time that occasionally Bath Stone was also known as Corsham Stone.

Bath stone, highly prized for being less friable than other types of Cotswold stone, also helped to create the town's superb architectural legacy. The finest

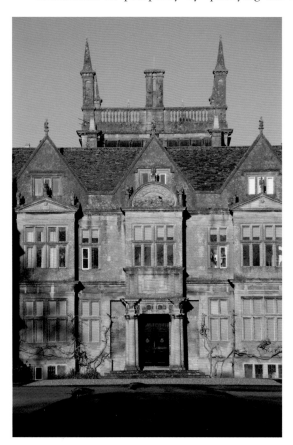

Corsham Court, the Elizabethan manor house.

house built from local stone is Corsham Court, which is also famed locally for the peacocks allowed to wander freely from its grounds around the town's streets. A superb Elizabethan manor house dating from 1582, it contains an extensive collection of sixteenth- and seventeenth-century Italian and Flemish Old Master paintings, including pictures by Reynolds, Rubens, Lippi, Turner and Van Dyck, as well as furniture by Robert Adams and Thomas Chippendale and parkland designed by 'Capability' Brown.

Located next to Corsham Court is the church of St Bartholomew dating from Saxon times and significantly restored in 1847 by George Edmund Street, a member of the Arts and Crafts movement. Another building of great interest is the Hungerford School and Almshouses, which were built in 1665 and have scarcely changed during the past 350 years. This magnificent complex of buildings was commissioned by Lady Margaret Hungerford and her husband, then the owners of Corsham Court, to provide accommodation for six poor people and education for ten poor students.

Among Corsham's literary associations is Charles Dickens, who chose the name Pickwick for *The Pickwick Papers* (1836) from Moses Pickwick, so called because he was an abandoned baby discovered in Pickwick, once a separate settlement but now forming an integral part of the town. Later, Moses Pickwick was brought up in Corsham's workhouse and then lived in the Hare and Hounds Inn from where, as a stage-coach proprietor, he ran coaches between Bath and London, from which connection Dickens came across the name.

48 Lacock

Lacock is now mostly owned and managed by the National Trust, and is an attractive village which lies 4 miles south of Chippenham. The village, whose name may possibly derive from the Old English Lacuc, meaning a small stream, is known to date back to Saxon times when a settlement existed around the Bide Brook. In 1232 Ela, Countess of Salisbury, founded an abbey here, which began as an Augustinian nunnery, in memory of her husband, William Longespee, a half-brother of King John, and who witnessed the signing of the Magna Carta in 1215. After becoming abbess in 1240, Ela obtained the right to hold markets and fairs at Lacock and, by the beginning of the fourteenth century, the village

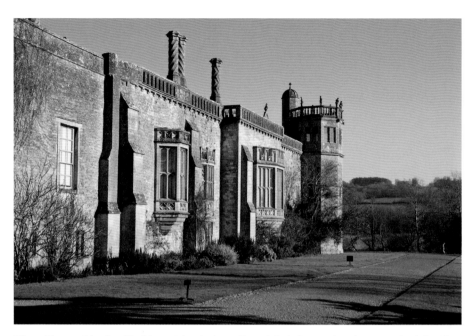

The abbey with the Gothic oriel window (far right) famously photographed by Fox Talbot in 1835.

had become prosperous based on its thriving trade in wool and cloth, helped by its proximity to the London to Bath road.

Following the Dissolution of the Monasteries, the remains of the abbey were initially converted by Sir William Sharington into a Tudor mansion following destruction of the abbey's church. Following its transfer to the Talbot family through marriage, some additional Georgian and later, Gothic-style alterations were made, including the insertion of two Gothic oriel windows by William Henry Fox Talbot. It was one of these windows that in 1835 became the subject of the world's first ever photographic negative, taken by Talbot himself. He later became known as the 'father' of modern photography, following the publication of his invention of the calotype process, through which any number of positive prints could be made from a negative.

From 1783, Lacock's economic fortunes took a significant downturn when a new road to Bath, the present A4, was built, thereby causing the old route through Lacock to become redundant. Consequently, with virtually no new buildings being constructed after the eighteenth century, the village became caught in a time warp, thereby enabling its almost complete preservation today. In 1944 the Talbot family bequeathed the abbey and the rest of their estate to the National Trust.

Other buildings of interest within the village include a superb fourteenth-century tithe barn, built in limestone, next to which is an eighteenth-century

lock-up, known as a 'blind house' since many of its occupants were frequently drunkards. Also of note are King John's Hunting Lodge, thought to pre-date the abbey, and the church of St Cyriac's, dating from the eleventh century and containing the grandiose tomb of Sir William Sharington. Given Lacock's status as a perfectly preserved village, it comes as no surprise to discover that it has been used as the backdrop for a variety of films and television costume dramas, from Harry Potter films to Jane Austen's *Pride and Prejudice* (1995) and Daniel Defoe's *Moll Flanders* (1996).

49 Bradford-on-Avon

Bradford-on-Avon is an attractive historic market town that lies in the Avon valley 7 miles south-east of Bath. Its history dates back to the Iron Age when a hilltop settlement overlooked the 'broad ford' from which the town takes its name. The town is first mentioned in AD 659 when the Saxon king Kenwalh fought a battle on the ford. Today, the ford has been replaced by a stone bridge dating from the fourteenth century, which, except for two arches, was largely rebuilt in the eighteenth century. Located on the bridge is a small seventeenth-century dome-shaped building, which was probably used as a chapel before being converted into a lock-up. Its weather vane is surmounted by a gudgeon fish, which gives rise to the local saying that the prisoners were 'below the fish and over the water'.

Much of the town's history can be appreciated through its small museum, which includes displays about its Roman past as well as exhibits about local trades such as stone quarrying and brewing. Its historical past can also be seen in its many interesting buildings, for example the tiny Saxon church of St Laurence, dating from around AD 700 and thought to have been built by St Aldhelm, the Abbott of Malmesbury. Originally belonging to a monastery destroyed by the Danes, the church became 'lost' among neighbouring houses for eleven centuries until it was rediscovered in 1856. Other churches of interest include the following: the medieval chapel of St Mary's, once used as a hospice for pilgrims bound for Glastonbury; the Roman Catholic church of St Thomas More, designed by the architect Thomas Fuller, who also built the Canadian Houses of Parliament in Ottawa; and the Trinity parish church, which is Norman in origin

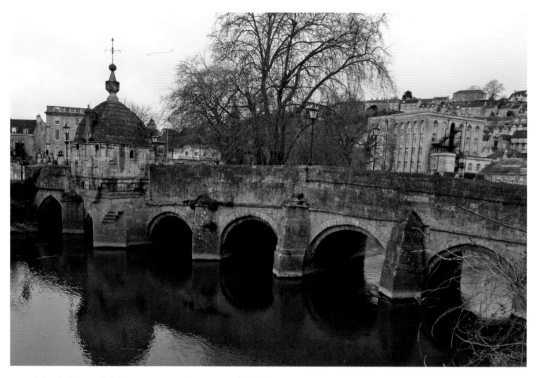

The bridge with its seventeenth-century building.

and was largely rebuilt during the fourteenth and fifteenth centuries. One of the town's special buildings is its large fourteenth-century tithe barn, now owned by English Heritage that once belonged to Shaftesbury Abbey, the richest nunnery in England. Each year, a tithe, or one-tenth, of the annual produce stored in the barn used to be given to the nuns.

From the Middle Ages until the late nineteenth century, the town's prosperity was largely based upon the woollen textile industry, indicated by the plethora of former woollen mills adjacent to the river and the terraces of former spinners' and weavers' cottages that occupy the steep hillside. Ironically, the Yorkshire mills, including those in the northern Bradford, began to prosper as Bradford-on-Avon's mills declined, partly due to the town's unwillingness to produce cloth of an inferior quality at a time when it was becoming more cost-effective to do so. Some of the overall decline was however offset through the completion of the Kennet and Avon canal in 1810, used to transport a variety of goods between Bristol and Reading, and the reopening of a redundant mill in 1848 as a pioneering rubber works, one of the first to apply Charles Goodyear's discovery of vulcanisation in Britain and which operated until 1994.

50 Bath

At the end of the 102-mile-long Cotswold Way path, starting at Chipping Campden, is the World Heritage city of Bath. The city owes its success not only to the natural hot mineral springs, the therapeutic properties of which the Romans discovered in the first century AD, but also to the availability of workable Cotswold limestone with which they built the spa town of Aquae Sulis around AD 54. The name Sulis referred to the Celtic goddess of the springs, with whom the Romans identified Minerva, their own goddess of healing and wisdom. The Romans then encouraged the Celts to worship Sulis at the Roman temple that they built and dedicated to Sulis Minerva. Although the town flourished for four centuries, its decline quickly followed the fall of the Roman Empire. Despite this, its importance increased again during the Saxon period, not least after Bath Abbey was chosen as the location for the coronation of King Edgar, the first king of all England in AD 973. However, it was not until the eighteenth century, following a visit by Queen Anne in 1702, that Bath's meteoric rise – once again due to its water and stone – took place, leading it to become a fashionable Georgian spa resort of national and international repute. As Daniel Defoe commented shortly after the queen's visit, 'We may say now it is the resort of the sound as well as the sick and a place that helps the indolent and the gay to commit the worst of murders – to kill time.'

Bath's transformation from a market town into a fashionable metropolis was made possible by three men. Firstly, the gambler Richard 'Beau' Nash, who became the Master of Ceremonies, establishing a new code of conduct that led to much improved social integration and helped to put Bath in the centre of the country's social fashion. Secondly, the postmaster Ralph Allen, who made his fortune by reorganising the nation's postal system, invested his wealth in the local Combe Down quarries and promoted the use of its oolitic limestone, previously used to build the Roman Baths, to construct the city. And lastly, the visionary architect John Wood the Elder who was commissioned by Allen to design many of the city's finest buildings, his work later being continued by his son who completed the magnificent Royal Crescent.

Not surprisingly, Bath is today richly endowed with museums and galleries, reflecting its unique cultural heritage. These include those covering the Roman baths, costumes, carriages, bookbinding, photography, toys and postal services. It also celebrates its literary, artistic and scientific associations through, for example, Herschel House, which is dedicated to the life of the astronomer and musician William Herschel, who discovered the planet Uranus, and the Jane

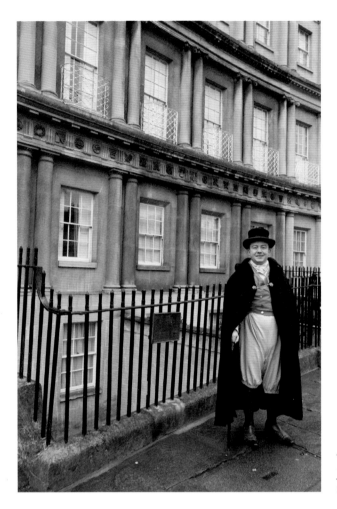

The Circus, one of John Wood the Elder's masterpieces.

Austen Centre, reflecting Jane Austen's Bath experiences when she lived in the city from 1801 to 1806, setting two of her novels, *Northanger Abbey* (1818) and *Persuasion* (1818), in and around the city. 'They arrived in Bath,' she wrote in *Northanger Abbey*. 'Catherine was all eager delight; – her eyes were here, there, everywhere, as they approached its fine and striking environs, and afterwards drove through those streets which conducted them to the hotel. She was come to be happy, and she felt happy already.'